AN INTRODUCTION TO
DRAWING FLOWERS

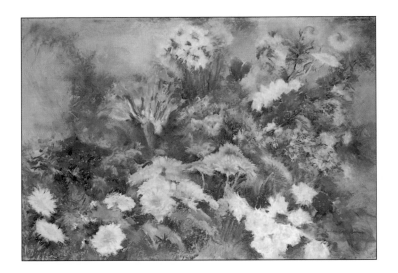

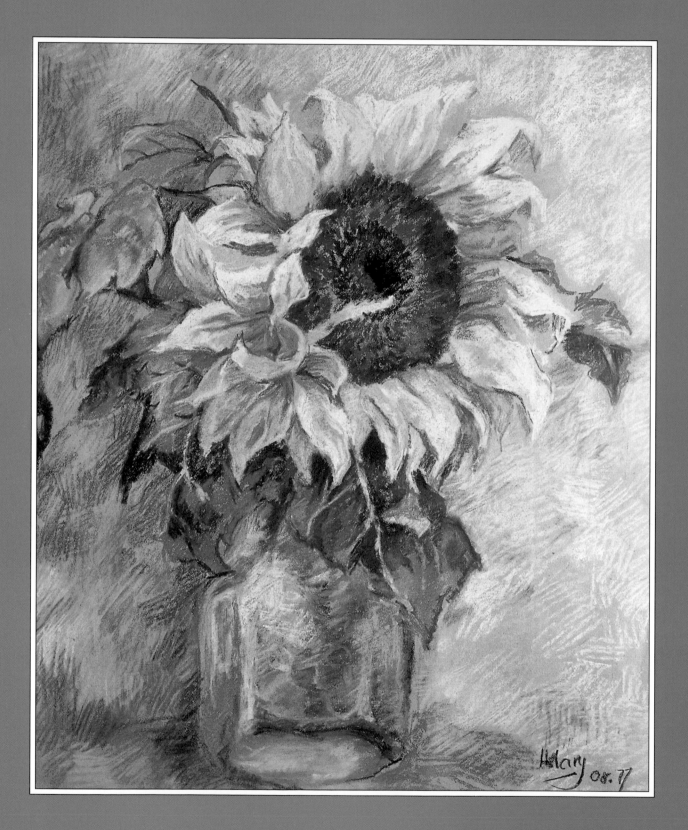

AN INTRODUCTION TO
DRAWING FLOWERS

FORM · TECHNIQUE · COLOR · LIGHT · COMPOSITION

MARGARET STEVENS

CHARTWELL
BOOKS, INC.

A QUINTET BOOK

Published by Chartwell Books
A Division of Book Sales. Inc
114 Northfield Avenue
Edison, New Jersey 08837

This edition produced for sale in the U.S.A., Its
territories and dependencies only.

Reprinted 2001

ISBN 0-7858-0159-6

This book was designed and produced by
Quintet Publishing Limited
6 Blundell Street
London N7 9BH

Creative Director: Richard Dewing
Designer: Ian Hunt
Project Editor: Helen Denholm
Editor: Geraldine Christy
Photographers: Paul Forrester and Laura Wickenden

Typeset in Great Britain by Central Southern Typesetters, Eastbourne
Manufactured in Hong Kong by Regent Publishing Services Limited
Printed in China by Leefung-Asco Printers Limited

CONTENTS

INTRODUCTION

Throughout recorded history the peoples of the world, regardless of individual cultures, have shown a common affinity in their regard for flowers. It is, perhaps, not too whimsical to believe that one of the highlights of an emerging civilization occurred when a member of a hunter-gatherer tribe paused to consider some blossom for its own sake and not just as a possible source of sustenance.

From Egyptian tomb paintings and jewelry to Greek pottery, the value placed on flowers in early decorative art is apparent. It is, however, the herbals which provide our strongest link with the botanical artists of the past. Frequently compiled by medical men as works of reference, they provide an insight into the native wild plants of many regions. One such herbal, the *De Materia Medica*, compiled in the 1st century AD by Dioscorides, a physician with the Roman Army, was still being used by a herbalist monk in Greece during the 1930s.

Over the centuries the quality of the drawings became poor and stylized, largely due to copying. What Chinese whispers do for the sense of the spoken word, so repeated copying altered the accuracy of the plant portraits. To identify medicinal herbs from these drawings must have been extremely hazardous, with the possibility of kill rather than cure. Small wonder that botanical gardens grew up around universities with medical schools, and better herbals were demanded by the students. From hand-drawn and colored illustrations, to crude woodcuts in early printed editions, improvement continued as these gave way to finer engravings and etchings.

Some of the more realistic portrayals of flowers occur on the illuminated manuscipts of the 15th century. Common flowers such as daisies, violas, camomile and dianthus, not to mention strawberries and ivy, are often shown against a background of gold

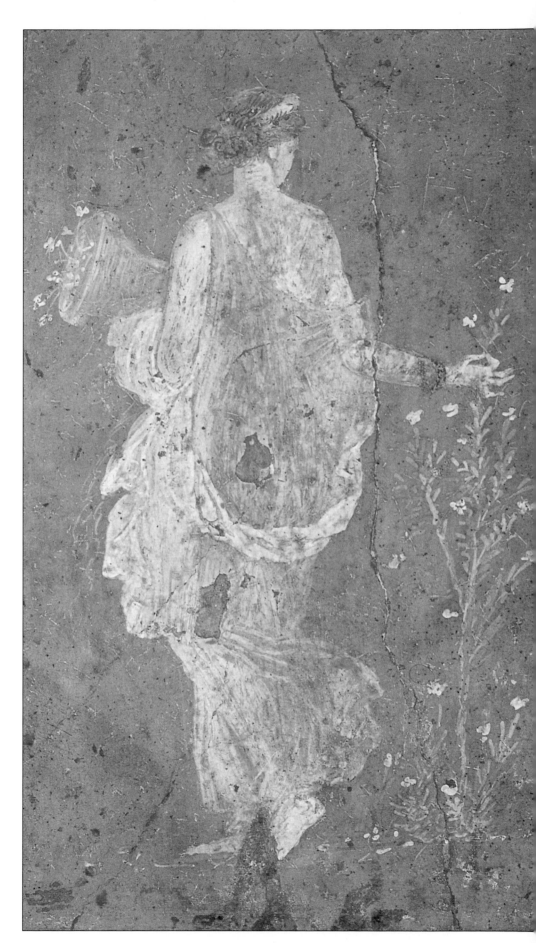

RIGHT **This Roman fresco (1st century AD) is painted in a vigorous and open style, giving life and delicacy to the flowers.**

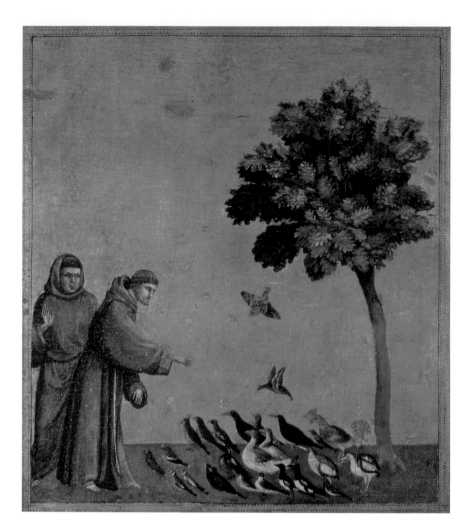

LEFT A fresco by Giotto in the Upper Church of St Francis, Assisi. St Francis' teachings encouraged Renaissance artists to include flowers and plants in their paintings.

an artist in its number. The job sometimes entailed map-making as well as providing a pictorial record of the new land and its flora.

Whereas in more recent years flower painting has often been seen as a gentle, ladylike occupation, in those days it would have been extremely hazardous. Certainly the New World held untold dangers, as men such as Jacques le Moyne de Morgue found out in 1565. The native Indians, with no reason to welcome Europeans, denied them food and later put many to a bloody death. Le Moyne and a handful of his colleagues were lucky to escape back to England. Later in his life he was responsible for one of the

leaf. In the early 16th century the Book of Hours of Anne of Brittany, richly adorned with around 300 plants, is part herbal, part devotional aid.

The teachings of St Francis of Assisi, with the emphasis on love for the natural world, encouraged artists to include flowers in major paintings. From the Renaissance we see fine examples of this, although the flowers are frequently endowed with their own religious significance. We see the rose adopted as the Christian symbol of love, the Madonna lily, *Lilium candidum*, representing the Virgin and also purity, violets for humility and the winged flowers of the columbine, *Aquilegia vulgaris*, portraying the dove of the Holy Spirit.

The Christ Child is also occasionally shown grasping a flower, as in the recently rediscovered work by Raphael, *Madonna with the Pinks*. In this exquisite small painting both Mary and the Holy Child hold a few simple dianthus. No doubt because of its shape, with a flat flower head, swollen calyx and stiff stem, it attracted another name, that of nail flower, and it became symbolic of the Crucifixion. So this portrayal of a tender moment between Mother and Child holds a note of foreboding.

Another change in the tide of floral art came with increasing world exploration. From the mid-16th century onwards each expedition which set out was likely to include

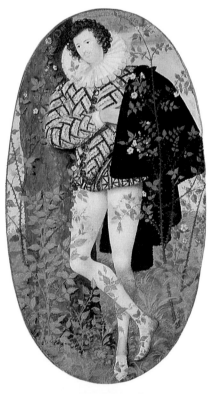

ABOVE *Young Man among Flowers* painted *c.*1587 by Nicholas Hilliard. Delicate rose branches have been used to frame this elegant miniature portrait.

earliest known books of embroidery patterns, one of the first, but by no means the last, flower painters to turn his talents to other areas for commercial benefit.

The chief contribution made by such artist-accompanied expeditions lay not in the number of botanical drawings but in the new plants and seeds that were brought back to Europe, particularly to the Low Countries. The number of new species available to the keen and wealthy gardeners of the 16th and 17th centuries increased rapidly. Evening primroses, rudbeckia, lilac, martagon lilies, narcissi and of course the tulip – all the flowers that crowd into the Dutch paintings, regardless of due season – helped to make this period rich for artist and gardener alike.

From this time, building to a peak in the 18th and 19th centuries, the true botanical artist was born, as all the splendor of these new varieties was captured in accurate drawings. Bound and reproduced as catalogs or floralegia, or executed for wealthy patrons, the great names of those days live on – Bauer, Ehret, Redouté and many others whose work set the standard for future generations.

With the Impressionists of the 19th century came change, and a looser, freer style of flower painting developed. This, together with Abstract Art to a lesser degree, continues to run alongside the more traditional realism of true botanical illustration.

The word "painting" in a book devoted to drawing flowers is used because, historically, a botanical watercolor is known as a drawing and is thus classified by museums. This probably came about because

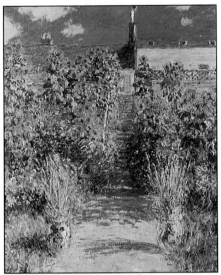

ABOVE Claude Monet's *The Terrasse at St Andresse*, painted in 1867, is an example of the looser style of flower painting developed by the Impressionists.

in such a drawing the background support, be it paper, parchment or vellum, remains visible and unstained.

On the other hand, pastels are also usually classified as drawings even though the whole of the paper surface is likely to be worked over. With the newer watersoluble pencils the whole boundary between drawing and painting becomes increasingly blurred. By the end of the book you will no doubt have formed your own opinion.

One thing is certain. The old saying, "God has the best palette", is never more true than when applied to flowers and probably explains why monchrome drawings do not hold the same general appeal as the humblest tinted sketch.

To hasten into color before grasping the principles of drawing is akin to putting the roof on the house without digging its foundations. Time spent in practicing draftsmanship will result in better paintings, no matter what style you adopt in the end.

ABOVE A modern painting of mixed flowers by Susan Hearson in the style of the Dutch Masters of floral art. One of the very few artists working in this style today, Susan Hearson paints in oil on board and builds up her paintings in the manner described in the chapter on Composition and Layout on page 35.

1
MATERIALS

Not all materials are suitable for flower drawing, certainly not when the object is to capture the delicacy of a petal or the fine line of a graceful stem. Learning to select the correct media for the subject matter under study is a vital part of the artist's job. Choosing the wrong material and in particular, incorrect paper, leads to much frustration. This chapter concentrates on those media and supports that are capable of yielding the best results.

DRAWING MEDIA

Pencils

Prior to the 17th century the word "pencil" actually referred to a brush, made of hair. Later it meant a holder for chalks, charcoal or pure graphite. Not until the late 18th century did wooden encased pencils, such as we recognize today, become the norm.

"Lead" pencils are made using a mixture of graphite and clay, the amount of the latter determining the hardness (H) or softness (B) of the pencil. A firm (F) pencil is desirable for outline work – for example, before watercolor painting. For normal pencil studies the range between H and 3B is usually adequate. When producing an outline on vellum, where only the palest gray line is desired, a pencil as hard as 6H may be used. At the other end of the scale a very soft 6B is useful for quick exercises in shading. Another good choice for outline work is a 0.3mm mechanical pencil filled with B leads. This gives exactly the right degree of density and delicacy of line.

Pure graphite pencils, which contain no clay, are available with or without a wooden casing and are graded in the same way as "lead" pencils.

Chalk pencils are available in traditional shades such as sanguine (red), terracotta and white, for highlighting on a colored support. These will produce drawings with a classic appearance but are more effective used on a larger subject, for example for drawing a sunflower rather than a cornflower.

Fusain, which is charcoal compressed into pencil form and graded for softness, is useful for very quick compositional studies, as well as providing the darkest element with other drawing pencils.

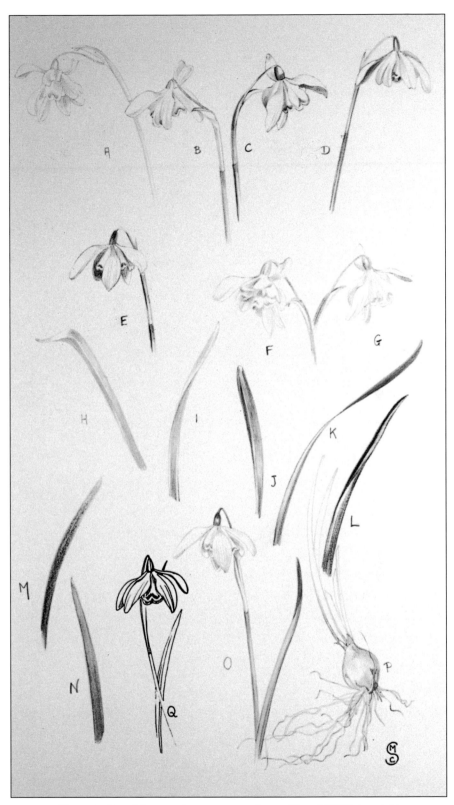

ABOVE These studies of the snowdrop by Margaret Stevens demonstrate the qualities of different media when portraying a very delicate flower. (A) and (H) Derwent Graphite 6H pencil; (B) and (I) Venus F pencil; (C) and (J) Derwent Graphite 2B pencil; (D) and (K) Pure Graphite; (E) and (L) Conté carbone; (F) and (M) Watersoluble pencils used dry; (G) and (N) Watersoluble pencils lightly touched with water; (O) Brush drawing in watercolor paint; (P) Bulb and roots executed with Pentel 0.3mm pencil; (Q) Edding 1800 Profipen 0.3mm.

Soluble pencils and crayons

When buying crayons you may consider purchasing the newer soluble varieties, which give you the best of both worlds. Used dry they work as a traditional crayon, and for effect and convenience the application of water, preferably distilled, to all or part of the drawing, softens it in a pleasing way. Some types require turpentine to be used instead of water. They are most useful for the artist working outdoors as they are easily carried and enable quick sketches and approximate color notes to be made on the spot. They are equally useful for producing quick color roughs where only a suggestion of the final color is required.

Made with pigment rather than dye, these pencils are variably lightfast, which should be remembered if working with a long-term objective.

ABOVE **A selection of drawing materials including lead pencils, colored pencils, watersoluble pencils and charcoal.**

Colored inks and pens

Inks too can be lightfast variable, though inks with acrylic, rather than shellac resin binders, tend to be less color fugitive. Likewise pigment rather than dye-colored inks are preferable. Once again one should consider whether the work is of the "throw-away" variety or for long-term enjoyment. The old favorite Indian ink is, of course, invaluable and like the colored inks may be thinned with distilled water. Do not be afraid to mix colored inks as some interesting shades are possible. For botanical illustration 0.1, 0.3 and 0.5mm technical pens are ideal. The black pigment ink is waterproof and lightfast. It goes without saying that any ink has to be waterproof if it is to be used in a line and wash drawing.

Traditionally, metal pen nibs, from the finest mapping pens to those with a wider nib, are fitted into a holder and a metal reservoir is attached which contains the ink. This allows for a wide choice of nib as, apart from a variety of widths, they are available with round tips and flat tips, all of which can create a confusion of choice. A sketching pen can be the answer, allowing you to build up confidence before trying other nibs. Like a fountain pen it can be filled with colored ink and is comfortable to use, but remember that Indian ink is unsuitable because it dries out and clogs up the flow. Technical pens which use ink cartridges are easy and clean to use.

RIGHT **Colored inks and nibs in two different sizes.**

Silverpoint

Pre-dating the modern pencil, this method of producing a fine drawing requires short lengths of silver wire, in varying gauges, a metal clasp holder and paper which is either commercially prepared or which you have prepared yourself.

Brushes

These should be the best quality that you can afford. As with so much else, really good work can be achieved only with fine implements.

A sable brush, although expensive, has a springy quality, unmatched by other hair and will give far longer service for daily use, though slightly cheaper brushes may also become favorites.

For the fine dry brush work and brush drawing which is so much part of a true botanical drawing the point is all important. Sizes 2 and 3 are both regularly used and for the finest work some artists like to go down to 0 or 00. This is a matter of personal choice, and some artists find the very small sizes too restrictive to be satisfactory.

BELOW Watercolor paints can be bought in tubes or blocks. Here are a few tubes, together with a variety of different sized fine brushes.

Watercolor paint

Once again it is advisable to buy the best paint that you can afford. There is a considerable difference between artists' and students' colors. Watercolor is basically pigment with a binder; in the better quality paints a type of gum acacia is used. When the cheaper dextrin is used this affects the pigmentation. A plasticizer for increased brushability is necessary and this may be glycerine or honey. The amount varies between pans and tubes.

The pigment should be lightfast for durability and good suppliers will always advise on this.

Gouache, known also as designers' gouache, is more likely to contain fugitive colors as the work is less likely to be kept in the long-term. Choose artists' colors in tubes or pans for their excellence in color range, handling and durability.

Papers and supports

For practice drawing any good cartridge paper in pad or sheet form is adequate. For more finished pieces of work in pencil, ink or watercolor you will find Hot Pressed (HP) watercolor paper, weight 140lb (300gsm), is very satisfactory. This is a good average weight for the requirements of the flower portraitist. The smooth Hot Pressed surface enables the artist to achieve very fine lines and detail. Among the most suitable are those made by Arches and Winsor & Newton. Fabriano Cold Pressed paper has a nice, fine "linen" texture, suitable for pencil, watersoluble pencil or watercolor drawings. The less experienced artist often finds this paper easier to work than the very smooth satin finish of Hot Pressed. There are instructions on stretching paper at the end of the book on page 125.

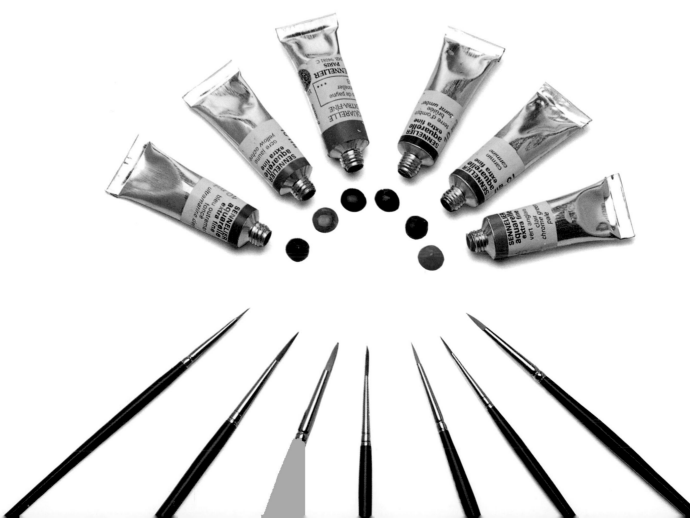

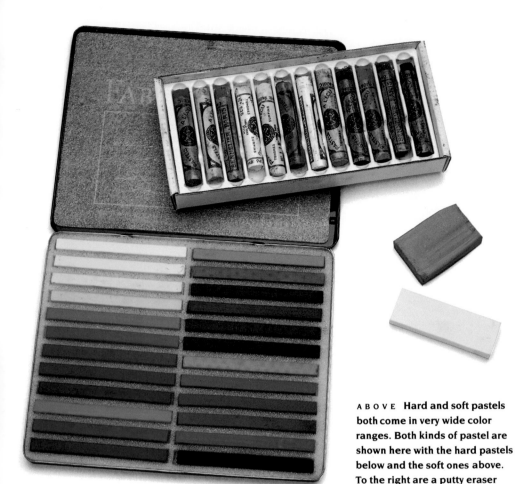

fairly expensive so perhaps it is best left for the more experienced artist.

Vellum, a traditional support for the miniaturist or calligrapher, also provides a lovely surface on which to set a flower study. Small pieces of ready-prepared vellum can be obtained from suppliers who specialize in the requirements of the miniature painter.

Ivorine is the modern plastic substitute for ivory and runs it a very close second in color and texture. Principally used by miniature artists, it also enhances the color and luminosity of the pigment when supporting a small botanical study. Like vellum it can be obtained from miniaturist suppliers.

Pastels

Chalk pastels when used on a suitable support allow the artist to express his or her vision freely.

Among the brightest are Rowney Artists soft pastels, which have an excellent range of colors for the flower portraitist. They are, however, a little too soft for use on flour paper. Talens Rembrandt are

ABOVE Hard and soft pastels both come in very wide color ranges. Both kinds of pastel are shown here with the hard pastels below and the soft ones above. To the right are a putty eraser and a plastic eraser.

BELOW A selection of paper, including watercolor papers in varying weights, and a range of tinted pastel papers.

Papers may be bought by the sheet or in blocks of various sizes. Blocks are a little more expensive but are extremely convenient and, unless you plan to get the paper very wet, avoid the need for stretching. All papers should be acid free in order to better withstand the passage of time.

Tinted watercolor paper such as Langton makes an attractive support for crayon, chalk or pencil, but remember that any paper will require stretching if it is to withstand a great deal of water, either through watercolor washes or with watersoluble pencils.

A more toothed NOT (Not Hot Pressed) paper will appeal when added texture is sought in some mixed media work. Pastels always require a toothed surface for the pigment to catch on, therefore NOT

or Rough is preferable to HP. Apart from the more usual tinted Ingres paper, fine carpenters' sandpaper or 00 flour paper makes an excellent pastel support. There is also velour paper with a cotton flock surface, available in pad form. Some of the colors are a little bright and it is

excellent, also Unison, although these have the gentle, muted tones more often associated with landscapes.

Fixative

The use of fixative is frowned upon by many artists and teachers. It is a synthetic product which will alter the colors of pastels, darkening them and making them less opaque. Careful storage of a finished work removes the need for its use.

Erasers

You will find nothing better than the modern plastic erasers made for use with pencil. Not only will they erase clearly without damage to the paper surface but they can equally well be used to "blot" out surplus density of color from a pencil line with great precision.

Putty erasers or even fresh bread will remove charcoal and pastel. While on the subject of erasers, it is useful to keep a few feathers handy.

There is nothing better than a gentle flick with a feather to remove eraser dust from the surface of your work.

SAFETY

A final word of warning. Remember some pigments are toxic, and care should be exercised when handling paint, pastel or ink. Sensible precautions and storage should be the norm, particularly if young children are around.

STUDIO OR WORKING PLACE

Every artist dreams of having the perfect studio with clear north light, yards of work surface and ample storage space. For most artists this remains a dream, and we learn to adapt and make the best of what we have. The following may be of practical help to you in planning your work area.

BASIC REQUIREMENTS

Light

If you have a north light you are truly blessed. If you have a mixture of light sources it can sometimes be difficult. Probably the flower painter can cope with this better than most artists, however, as the subject is generally portable and blinds or curtains can exclude the direct sunlight at certain times of the day. Only for a few weeks of the year is it really troublesome, and a large sheet of corrugated cardboard, can serve as a temporary blind, allowing work to continue. Another solution is a screen placed to shield the working area, thus taking the glare off the paper while not cutting down on precious light.

It is always preferable not to work in artificial light, although, of course,

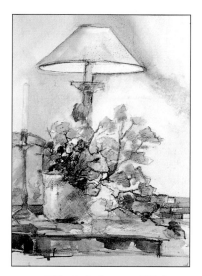

A B O V E **This study, *Lamp and Winter Plant*, by Norma Stephenson, makes good use of the light source as the glow of the lamplight intensifies the green ivy leaves. It is drawn in ink, pastel and watercolor.**

it is sometimes necessary. A 100 watt daylight bulb is very useful, giving a good clear light which enables you to judge color well. Placed in a desk lamp it does generate a lot of heat, however, sufficient to wilt a delicate flower, and this is something to beware of.

Work surface

It is essential that the height of the desk or table is correct for you and that equally applies to your chair. If you are to spend long hours sitting

in one position a comfortable chair is essential. Few flower artists work with an easel, unless they work in oils, or less frequently, acrylics. Back and neck ache, even tennis elbow, are possible problems, so it is wise to get up and move around from time to time. You might be surprised to discover how tiring drawing can be.

Arranging equipment

It is important to lay out your equipment in an organized fashion. Assuming you are right-handed, the subject you want to draw is best placed either directly in front of you or towards the left, at a comfortable distance so that you can see it clearly. The drawing board or block should be propped up slightly in front of you, although you may prefer to work flat. If you are using water the pot should be stood on several folded sheets of paper towels. This is important as it enables surplus water to be dabbed off the brush quickly and in the case of spills provides a first line of defense in mopping up. Paints should be on the left-hand side. Brushes and pencils to the right. Of course, this does not apply when using crayons, pastels and so on, but only when water is involved.

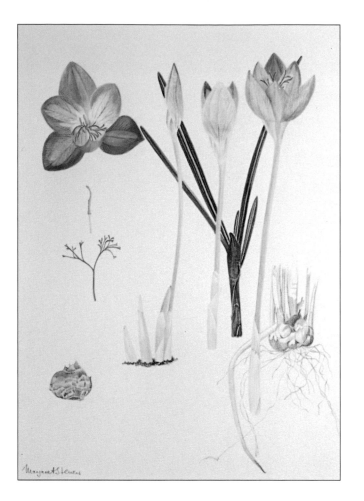

There is no sight more guaranteed to raise the blood pressure of a caring teacher than that of a student holding a flower, which will obviously take an hour or two to paint, while unwanted flowers are scattered on the desk and left to die. Over the years, observation and experience have shown that really good work is produced only by those with a sincere love of and respect for flowers and plants. If you truly love something you do not treat it with indifference, and you certainly do not kill it.

Some flowers are best left uncut and although in many cases only florists' cut flowers are available to the artist there are many that are pot-grown either commercially or at home on the patio or in the yard. Of the commercially grown ones, colored primroses, cyclamen, pot chrysanthemums, azaleas and small spring bulbs are usually plentiful. At home you can also grow numerous pots of narcissi, tulips, pansies, camellias, lilies and many others, all of which never need to be cut. Bring the pot indoors for the hours of work and take it back outside as soon as you have finished.

Positioning flowers

Having settled comfortably, other problems occur and one of these is likely to be the difficulty of working with certain flowers. Some, like crocuses, are notoriously difficult to draw and anemones are not much better. It makes no difference if you have grown the crocus in pots especially to paint, for as soon as they come into a warm atmosphere – or even quite a cold one – they open furiously. So, turn off the heating, open the windows, put on your coat and scarf, then fetch in the crocus. Work fast and you *may* be lucky enough to capture the flowers at the peak of perfection. Some flowers, in particular roses, will last very well if kept in a vase of fizzy lemonade and stood in the fridge when not required. They will last up to a week in this manner.

ABOVE **This pot-grown autumn crocus by Margaret Stevens typifies the difficulty when working with this species indoors. The pot was moved in and out several times in the day in order to prevent the flowers opening beyond the point of no return.**

Remember that not all flowers are happy in florists' foam – soft-stemmed flowers such as poppies and primulas are among these. It is largely a matter of common sense and for the most part it is preferable to work with a flower in a specimen or other appropriate vase. Students have been known to try and force primroses and pansies to look cheerful with their stems secured in foam. Even if you make the holes for them they will not like it and the cry will soon go up, "My flower has changed", and there is only one answer, "Yes, you have killed it".

ABOVE **A continuous line or contour drawing of a primula by Jean Elwood. In pencil and watercolor, it captures the fresh image simply and effectively.**

PLANT ANATOMY

Just as the artist who draws the human form benefits from a knowledge of the skeleton beneath the skin, so the botanical artist needs an understanding of how plants are made up. Unlike the human body there are many variations and the following information will provide a useful reference point.

The large sub-division of the plant kingdom known as the Flowering Plants all bear seeds enclosed in fruits, though the structure which produces them may not readily be recognized as a "flower", as is the case with grasses or catkins, for example. The rest of the body of the plant is typically made up of stems, leaves and roots, any one or more of which may be absent.

The leaves are responsible for converting light energy into food for the plant.

The stem supports the leaves and flowers; it may be a massive perennial structure such as a tree or reduced to an underground rhizome or corm. It bears the flower stalks (pedicels), each of which ends in a "receptacle", or in the stalk of an inflorescence (a peduncle). The receptacle supports the parts of the flower, all of which are modified leaves, and these are arranged in "whorls" in a basic plan which is easily seen in a simple open flower such as the marsh marigold or buttercup. The whorls, in order from the outside, are sepals, petals, stamens and carpels.

THE FLOWER

The flower is the reproductive organ of the plant and is dedicated to producing seeds. These develop from ovules and will eventually be enclosed in a fruit, which is "succulent" or "dry" according to the method by which the seeds are to be dispersed.

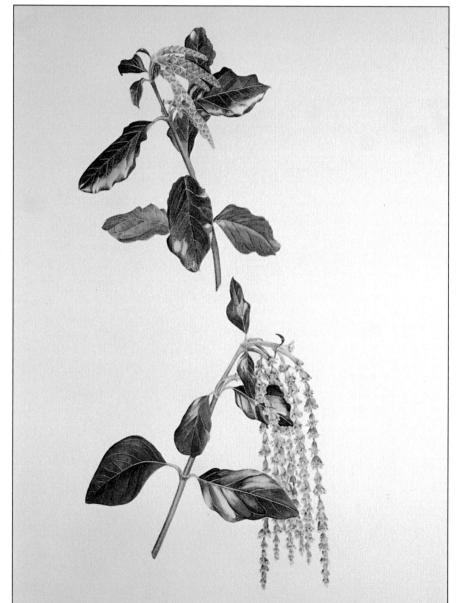

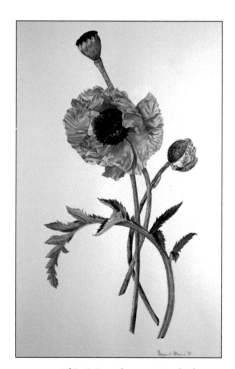

ABOVE This Oriental poppy "Turkish Delight" by Margaret Stevens is a good example of a flower with a hairy stem and calyx. No white paint has been used as the "white" hairs are suggested by leaving the paper exposed with dry-brush technique. No black paint has been used for the stamens — a mix of purple, French ultramarine and Vandyke brown gives a good approximation — with more red, such as crimson lake, in the filaments of the stamens.

ABOVE A winter-flowering shrub, *Garrya eliptica*, which thrives in a north-facing aspect and produces fine catkin tassels, is drawn here by Margaret Stevens. The complicated structure of the tassels requires careful brush drawing. To pre-draw in pencil is unnecessary and time wasting, and is likely to create a more muddy effect when paint is applied.

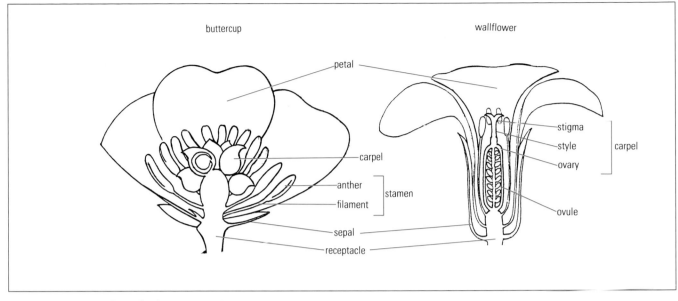

A B O V E **Dissection through a buttercup and a wallflower.**

Probably the best aid to an understanding of flower structure is to make dissections of individual flowers. This requires a minimum of equipment: a craft knife or razor-blade, a tile and a hand lens. In many flowers, simply pulling the floral parts off the receptacle in order from the outside and laying them out on the tile will reveal their number, sequence, arrangement and mode of attachment. For any type of flower, especially the more complex, the most instructive dissection is a vertical section or half flower. The flower is cut in half along the plane, which gives two mirror images, and this shows the anatomy in situ. The diagrams shown directly above were made after using this method.

The sepals are known collectively as the "calyx" and the petals as the "corolla", but where, as in tulips or aquilegia, the two are indistinguishable, they are usually referred to as the "perianth". Within these whorls are the stamens. In the center are the carpels which may be fused together, as in the wallflower illustrated above.

The floral parts usually alternate so that the sepals are not opposite the petals but between them for support. After fertilization the ovules become seeds and the ovary develops into a fruit.

The sepals or petals may be pouched, as in viola and aquilegia, to form one or more spurs, which hold nectar. Cultivation and selective breeding have altered the form of many flowers, as is apparent in the rose. In so-called "double" flowers, there has been a tendency to increase the number of petals at the expense of the stamens.

FLOWER FORMS

The simplest flower form is "regular" and open, for example magnolia or anemone. Such flowers are usually pollinated by a variety of short-tongued insects. Others, such as primula or convolvulus, are regular and tubular and tend to attract mainly long-tongued pollinators such as bees and moths. The most specialized are bilaterally symmetrical or "irregular", for example orchid, pea and sage. These have evolved to fit particular insects, thus ensuring that the pollen is carried only to the same

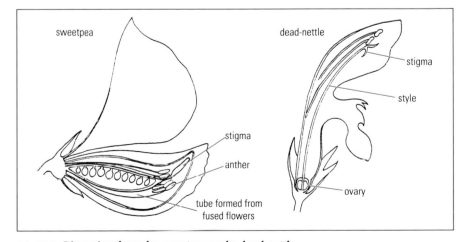

A B O V E **Dissection through a sweetpea and a dead-nettle.**

species and not deposited on alien stigmas where it will not germinate. The irregular flower "lines up" the approaching insect to ensure that it both picks up and deposits pollen accurately. In such complex flowers the sequence of the whorls may be difficult to see as the filaments may be fused together, as in sweetpea, or fused to the petals, as in foxglove. They may even be absent as in the orchids. The stigma, too, may be displaced to one side, as in sage and dead-nettle.

The inflorescence

Flowers which are grouped together into an inflorescence are usually at an advantage over solitary flowers in attracting pollinators or dispersing pollen on the wind. The arrangement of the flowers on the stalk follows a variety of patterns, the type of inflorescence being very

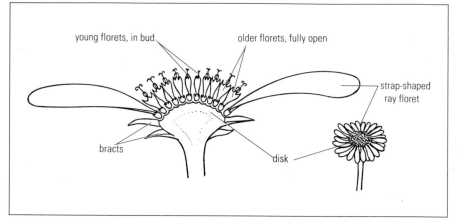

ABOVE **The capitulum of a daisy.**

characteristic of different flower families. The simplest is the "raceme", a column of flowers with the oldest at the bottom and opening in succession to the top, as in foxglove or gladiolus. Where all the flowers radiate from the same point, those which are oldest and have the longest pedicels will be on the outside and this gives a flattened umbrella shape called an "umbel".

Botanists distinguish many other designs but one of the most complex and successful is the "capitulum". This is a compact plate of tiny flowers without pedicels, borne on the flattened top of a stem. The youngest are still in the center, and the older florets spiral outwards towards the edge of the disk. Each of the outer circle of florets usually has a strap-shaped corolla which resembles a petal and the whole capitulum looks like a single flower. The daisy is a very good example of this. This close grouping of so many florets enables small short-tongued insects to crawl over the capitulum, and effectively pollinate most of the stigmas.

A compound inflorescence consists of an arrangement of several inflorescences, as in spray chrysanthemums or tansy.

LEAF FORM

A typical leaf is made up of a lamina (blade), a petiole (stalk), and a base. This is usually just a slight swelling where the leaf joins the stem.

The lamina is supported by a framework of veins, best seen in the leaf skeletons found under trees at the end of winter when the soft parts have rotted away. It is possible to prepare such skeletons from intact leaves by soaking them in caustic soda solution. In life, the petiole twists to bring the lamina into the best position to receive light and avoid being shaded by the leaves above. If the direction of the light changes while the plant is set up for drawing, subtle responses of this kind by the leaves may alter the composition.

The lamina takes a wide variety of forms and textures in different species, usually related to the habitat of the plant. Leaves such as those of apple or beech have one prominent midrib with veins branching off to form a network throughout the lamina. The veins may branch off regularly in pairs but more frequently they are staggered. Each vein may run to a "tooth" or may loop back to join the network of veins near the edge. In others, such as begonia or pelargonium, the

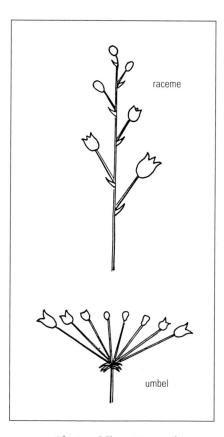

ABOVE **The two different types of inflorescence.**

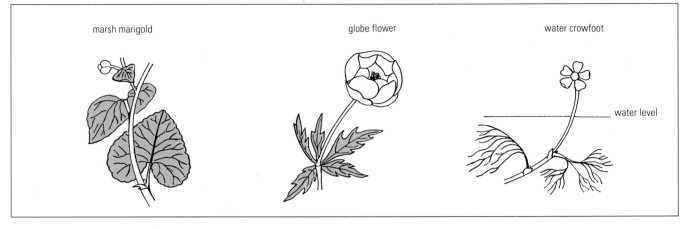

A B O V E **The variety of leaf shapes present in different members of the buttercup family.**

A B O V E **A botanical study of *Narcissus* "Easter Bonnet" by Margaret Stevens. It demonstrates the long, strap-like leaves with veins running upwards from the base.**

The part of the stem from which a leaf grows is called a "node". The arrangement of the leaves on the stem is characteristic of the species and usually falls into one of three distinct categories. The sequence may be "alternate" (spirally arranged as in the Cruciferae family such as wallflowers), "opposite" (as in the sage family), or, less commonly, "whorled" (as in the bedstraws).

LEAF SHAPES
The shape of the leaf can be used to identify a plant and may vary considerably within a family; for example, compare the heart-shaped leaves of marsh marigold with the thread-like ones of water crowfoot,

lobed leaf-blade is supported by from five to eight main veins of equal status radiating from the petiole, each supplying one lobe with its own network.

The strap-like leaves of monocotyledons, which include lilies, irises and grasses, have parallel veins from the base of the leaf and no petiole or very distinct base. In grasses, the lower part of the leaf runs down the stem to form a sheath.

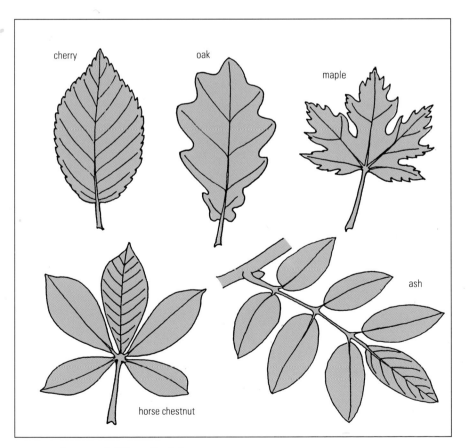

A B O V E **A range of different leaf shapes.**

or the divided leaves of globe flower – these are all members of the buttercup family. Sometimes, as in holly or hedge mustard for example, the shape of the leaf differs in different parts of the same plant.

Botanists distinguish dozens of different leaf shapes and have managed to find Latin terms to describe them all, but basically the lamina may be either simple or compound, and the margins may be entire, lobed, toothed or cut.

At first sight, a compound leaf, such as that of ash, may be mistaken for a stem bearing simple leaves, particularly if the leaflets are

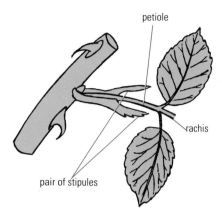

ABOVE **The base of a rose leaf showing the stipules.**

stalked, but wherever a whole leaf is joined to a stem there is a bud in the axil (the angle between leaf-base and stem). There is no bud in the axil of a leaflet.

Paired "stipules" may be present at the leaf base and are characteristic of some flower families, for example the Rosaceae. They may resemble leaves or threads or be reduced to scales.

Leaves and stems may bear hairs, sometimes so dense as to give the plant a woolly appearance or sparsely scattered and occasionally glandular. There may be thorns or prickles on stems and leaves. All these appendages have functions important to the life of the plant and give it its essential character.

PLANT ANATOMY GLOSSARY

Anther The part of the stamen that makes pollen.

Axil The angle formed by the leaf-stalk where it springs away from the stem.

Bract A modified leaf at the base of an inflorescence.

Calyx A collection of sepals.

Capitulum A compact inflorescence of sessile florets in the form of a disk.

Carpel The female part of the flower, containing one or more ovules.

Compound leaf A leaf made up of several distinct leaflets.

Corolla A collection of petals.

Filament A small flower forming part of an inflorescence.

Habit The form of growth characteristic of an individual plant.

Inflorescence A stalk bearing flowers, with their bracts and pedicels.

Node The point on the stem where one or more leaves are attached.

Ovary The part of the carpel, or fused carpels, which contains ovules.

Ovule The organ in the ovary that after fertilization becomes a seed.

Pedicel The stalk of an individual flower.

Peduncle The stalk of an inflorescence.

Perianth The outer, non-sexual, whorls comprising the sepals and petals collectively.

Petal One of the second whorl of floral parts.

Petiole Leaf stalk between the midrib or rachis and the base.

Rachis The axis of a compound leaf, which corresponds to the midrib in a simple leaf.

Sepal One of the outer whorl of floral parts.

Species A group of freely inter-breeding plants (or animals) which share many characteristics.

Stamen The male part of the flower.

Stigma The part of the carpel on which suitable pollen germinates.

Stipule An appendage, usually paired, at the base of the leaf stalk.

Style The part of the carpel between the ovary and the stigma.

Whorl A circle of leaves or floral parts.

3
FORM AND PERSPECTIVE

Following on from basic observation of plant shapes the artist needs to study the natural form of the plant and how its components appear to alter when they are viewed from different angles. Without this awareness any artwork will look flat and lifeless, as well as botanically incorrect, instead of lively and three-dimensional.

FORESHORTENING LEAVES

To the beginner it often seems that the very word "foreshortening" is the gateway to difficulties, but that need not be so. Remembering certain elementary facts will help to make it easier, as the following simple exercise will demonstrate.

In your left hand hold an object such as an audio cassette level with your eyes and totally vertical. In your right hand hold a ruler against it. You will see that it measures approximately 3in (7cm). While keeping the ruler in position, tip the cassette away from you. As it tips back the reading on the ruler decreases. Stop when the top edge reaches 2¼in (5.5cm). You have foreshortened the cassette. You will also see that the top corner of the cassette has apparently moved away from the vertical ruler and that the back edge appears to be narrower

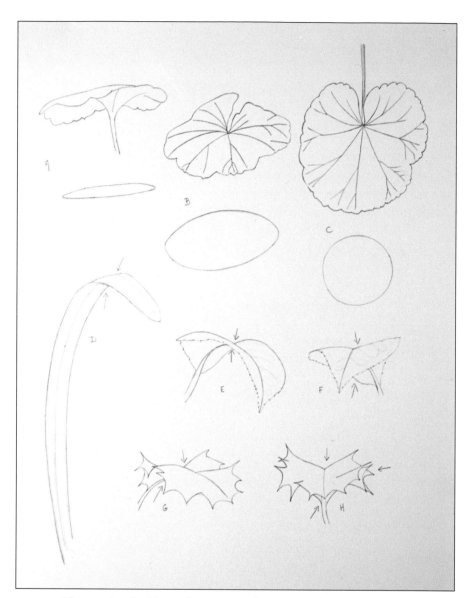

ABOVE **These various leaf forms show the effect of forshortening: the geranium which changes in shape from cigar (A) to rugby ball (B) to soccer ball (C) in overall outline; the monocotyledon (D), arrows draw attention to the point where mistakes** often occur as the midrib emerges from the blind spot; (E) and (F) demonstrate the same feature on camellia leaves; (G) and (H) again arrow the midribs and highlight the predatory appearance assumed by the holly when it is viewed head on.

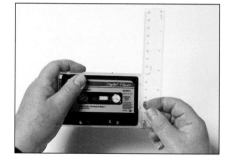

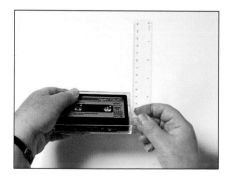

ABOVE **These photographs demonstrate foreshortening with the aid of a cassette case and ruler. The further away you tip the cassette, the more it becomes foreshortened.**

than the leading edge. This is perspective. If you continue to tip the cassette back the surface area gradually disappears from view until you are looking at the edge of the cassette, which measures approximately ½in (1.5cm).

Now substitute a simple leaf shape for the cassette and tip that in the same fashion until you are holding it on the horizontal. You will be looking at the edge of the leaf, with the least amount of surface area exposed.

With practice, drawing such leaves will come naturally and a useful maxim is to trust your eyes. Often the shape is so different to what you expect to see that you cannot quite believe it. This is certainly the case with more complicated leaf forms such as holly. Used as we are to the

simplified decorative, often stylized holly leaf of Christmas decorations we forget that it is as beautiful an example of a sculptured leaf as we can expect to see. When viewed at the horizontal the spines appear to be set one behind the other. At that point the familiar holly leaf takes on the appearance of an alien insect, sharp legged and predatory.

The more familiar you become with the handling of leaves, studying the changes in shape that occur, the less daunting they become. Linear leaves such as daffodils often seem to present an easier shape to cope with. Frequently it is only the upper length of the leaf which tilts towards the artist. Perhaps it is easier, but one golden rule remains – the midrib must continue without a break, even where it is no longer in view. All too often the less experienced artist draws the midrib from the leaf stem quite correctly; then, as the leaf turns, the midrib disappears from view, only to re-emerge at an impossible angle. When drawing leaves as an exercise lightly sketch in the midrib throughout the turn. That way you will come to realize that it always follows the curve.

While on the subject of leaves, the student often lacks confidence when drawing the long sweep of a linear leaf. In fact drawing the second, parallel line of leaf or stem can be quite difficult, even for an experienced artist. It becomes even more tricky when the lines run close together, as with some ribbed leaves or very narrow stems. Several things will help. One is attitude of mind. If you feel relaxed, all drawing, however testing, becomes more fluid and therefore easier. Tension creates unsteadiness. It can also be helpful to draw with a piece of paper

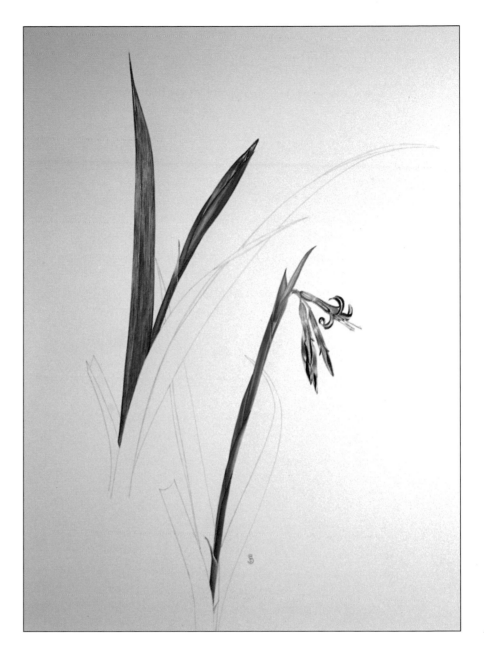

under your hand, which will skid over the surface of the drawing paper. You should always have a sheet of something like paper towels under your hand in any case, as it is pointless buying acid-free paper if you then contaminate it with acid from your skin.

One artist always uses little knitted squares for this purpose as they are soft enough to give the right degree of skid. Even pulling the knitted cuff of a jersey down over the hand can be helpful when skating over the paper.

ABOVE Apart from showing the need to practice the skills required in order to depict the monocotyledon leaf, this study of billbergia by Margaret Stevens typifies the situation often faced by the botanical artist. A plant shows signs of flowering at an inconvenient time for the artist, so rather than miss it, paint the flower spike, then a day or two later paint it again as the flowers break forth. This way the wonderful color is captured. The flowers of the billbergia are short lived whereas the leaves last for weeks, so it is only necessary to draw those in and paint one to give color guidance. The artist chose this leaf particularly because of its silvery sheen towards the top.

DRAWING STEMS

It is a fact that if you draw towards a given point rather than away from it you are more likely to produce a sweeping, accurate line. This is more useful when drawing stems. Picture the long sweep of a tulip stem. Instead of starting at the bloom start the line at the required distance away from it and, keeping your eye on the point where you wish to make contact, bring your pencil towards it. You are more likely to score a direct hit with this method. The nearest everyday example is when cutting across a wide piece of fabric – keeping your eye on the far selvedge enables you to get a straight cut. If you watch the scissors you will end up wide of the mark. So, on some

scrap paper mark a cross, keep your eye on it and from about 14in (35cm) away, sweep your pencil towards it. Repeat this until you feel confident.

While on the subject of stems it is worth mentioning that often there is a variation in thickness between leaf joints, often seen on roses. A typical example is the carnation. These are the times when drawing a long stem becomes easier to cope with as one works between the leaf joints rather than along the whole length.

Hirsute or hairy stems should be looked at carefully before drawing. The hairs are never regularly positioned, so do not be tempted to draw them without due regard for the way they are spaced. Neither do they all emerge from the stem at a

45 degree angle, or indeed from the "edge" of the stem. Some will protrude from the stem surface with only the tip of the hair silhouetted against the light. In some ways the hairs look finer when drawn towards the stem rather than away from it, but whichever way you choose, delicacy of touch is essential.

B E L O W **An example of various stems and their differences by Margaret Stevens showing: (A) the carnation with the change of thickness between the joints; (B) the rose stem, which has a distinct variation in angle between the joints; and (C) the sweeping curve of the tulip where light catches both edges of its stem so that the darkest shadow is confined to the central area.**

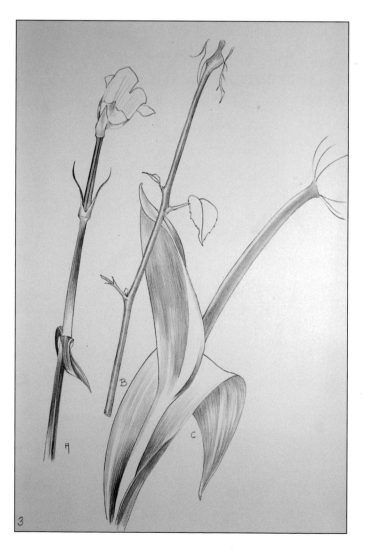

FORESHORTENING FLOWERS

Foreshortening flowers never seems to pose the same mental block as foreshortening leaves. Perhaps this is because we tend to think of flowers in more human terms, either full face, semi-profile or full profile. It is no accident perhaps that we think of pansy "faces" or the "mouth" of the snapdragon. For whatever reason, a composition of all full-face flowers would be very boring and it is necessary to include other profiles to give depth and interest.

A flower seen in profile, either from front or back, has more pegs on which to hang the drawing. In the former the configuration of petals around the bud provide focus, whereas in the latter sepals and calyx add a different dimension.

When tackling any flower, particularly for the first time, it is helpful to decide on its overall shape, regardless of detail. Take rough measurements with the pencil, literally against the flower, at strategic points, and mark these lightly on your paper. Then link these marks with straight lines to give you a grid on which to place your drawing.

A full-face flower can be awesome if composed of a multitude of petals. Some roses and most carnations fall into this category. Again, a grid of the overall shape will help. It enables you to decide on a starting point and to keep track of your movements when drawing the surface of the petals. The eye becomes confused by such a mass of detail, but aiming for focal points provided by the grid will be a help. In the illustration opposite you will see that the carnation is widest below the halfway line. The lowest angle is the most obvious starting

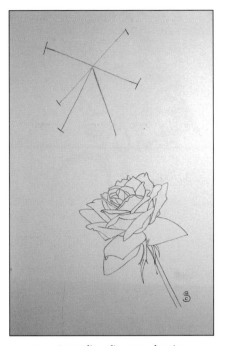

ABOVE **An outline diagram showing the semi-profile of a rose viewed from the front.**

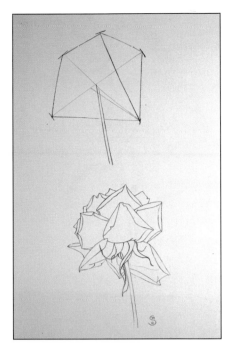

ABOVE **The same rose viewed from the back. Such initial outline diagrams help to establish the overall shape of the flower before drawing commences.**

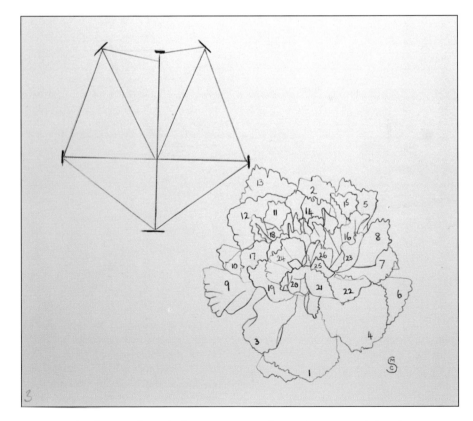

ABOVE **This diagram shows the basic shape of the carnation bloom under scrutiny, and the numbered petals indicate the order in which each petal was drawn. Selecting the largest petal** as the starting point and then drawing its diagonal soon builds up a complicated flower. This method avoids confusion of the eye, which can arise when tackling a multi-petaled bloom.

point, so the artist draws in that petal and numbers it. Then she puts in the small petal numbered 2 at the top. By concentrating on the petals one at a time and according to their position, you can work without confusion. Because the artist numbers each petal as she works, you will see that the sequence is not what you might expect. By picking out the diagonals, such as Nos 7, 8, 9 and 10, the overall shape is built up far more accurately than by starting at the 12 o'clock position and working around as if on a clock face. With practice such a method of working becomes commonplace.

Mention of the clock face brings to mind the Compositae family of daisy, chrysanthemums and so on. Some of the larger members of this group can be confusing, and it is all too easy to run out of space before all the petals have been filled in. The easy way, for a full-face bloom, is to treat it exactly like a clock with a rough circle marked off at 3, 6, 9 and 12 o'clock. Start at 12 and put in the petal nearest to that position. Next draw in the one at 6, then 3 and lastly 9 o'clock. Now draw only the petals between 12 and 3, followed by those between 3 and 6 and so on. This way you only need to focus on a small area and you can pick out individual petals which may have a twist in them or some other distinguishing feature.

Now a few words on another common difficulty, that of drawing tubular flowers such as daffodils, in semi-profile. Start by drawing an ellipse, a regular oval. Then draw the petals, making sure that the tip of each one is capable of touching the line of the ellipse. The corona, trumpet, will probably project beyond the ellipse, although, of course, this depends on the variety of daffodil. Now make sure that the corona, the tube behind the petals and the stem all line up. Just as with the midrib in a twisting leaf, this characteristic is not always recognized by the student.

Perspective in flower drawing does not play the same part as it does in the more obvious fields of landscape or townscape. When working with flowers it is more a matter of common sense to realize that, on a plant or in a large composition, objects are marginally smaller as they recede from the forefront of the study.

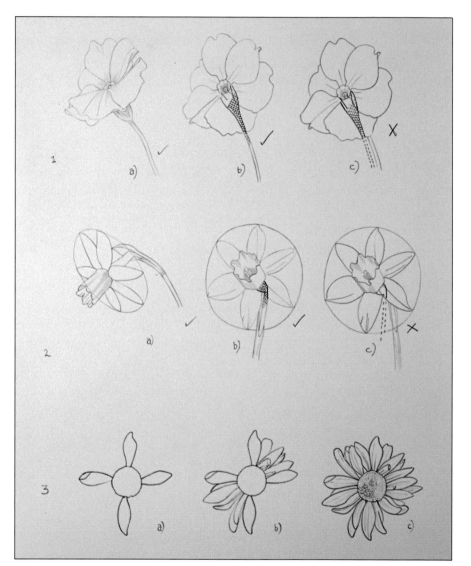

ABOVE This illustration demonstrates the right and wrong way of dealing with stems emerging from the blind spot of tubular flowers seen in semi-profile. 1(A) There is no problem with this profile of a primrose as the calyx and stem are clearly visible. 1(B) Again the stem emerges from the correct spot with the cross-hatched "see-through" section showing how it links, through the calyx, to the center of the flower. 1(C) Here the stem is too far to the right and should follow the dotted line. In 2(A) we see an almost full-profile daffodil with the tips of its petals touching the line of the ellipse and a correctly drawn stem. 2(B) is also correct whereas 2(C) again shows the stem drawn well off course. The upward tilt of the flower demands that the stem should curve beneath it, again following the dotted line. 3(A) shows the start of a drawing of a daisy-type flower using the clock method. 3(B) Here the petals are being gradually filled in and 3(C) shows the completed flower.

LINE AND MOVEMENT, LIGHT AND SHADE

However realistic the interpretation of the subject it is still desirable to produce a study that is lively. This is perhaps easier for the freestyle artist, but the botanical artist can also achieve that same quality of freedom in the curve of a stem or line of a petal. Georg Dionysius Ehret was one of the first to achieve this happy balance between art and science, a balance still worth striving for today.

LINE AND MOVEMENT

As mentioned earlier, working in a relaxed position and indeed, a relaxed frame of mind, helps to achieve a fluid line. For this reason it can be helpful, whether in a class or working at home, to produce a "minute" study. This exercise, done on scrap paper with a soft pencil, crayon or charcoal, should be carried out in a timed minute to be worthwhile. To begin with the prospect can be terrifying, and instead of relaxing you may find yourself becoming tense, but gradually you will relax and the whole character of successive studies you draw will change. Even quite capable draftsmen can be affected as you can see in the first "minute" study of a tulip opposite. The wavy lines speak of almost knotted muscles in hand and arm. This is much improved in the second study and certainly different from the more finished piece of work, showing the same tulip, later that morning.

It is easier to achieve the desired effect with flowers such as tulips, which curve their stems gracefully, and less so with a more rigid subject, such as a spray of winter jasmine. A common error is to show the subject at the wrong angle, often contrary to its natural growth. Left to its own devices winter jasmine will arch and become quite graceful, for all its spiky twigs. Draw it upright on the page and it looks harsh and

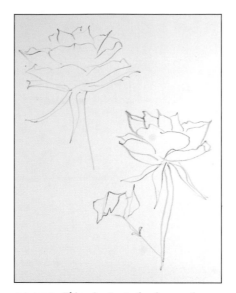

ABOVE **This minute study of a rose by Maggie Parker was executed at the start of a day course. This is a useful way of freeing muscular tension, as well as focusing the eye.**

ABOVE **A study of the same rose by Maggie Parker using conté pencil, showing the not unusual error made when the stem and calyx fail to make contact with the center of the bloom.**

RIGHT **A "spur of the moment" study made by Margaret Stevens when this outsize aquilegia seedling appeared in the garden. These Granny's Bonnet flowers are among the gems which need no formal arranging, seeming to fly across the paper at will. No wonder that they came to represent the dove of the Holy Spirit in floral reglious symbolism.**

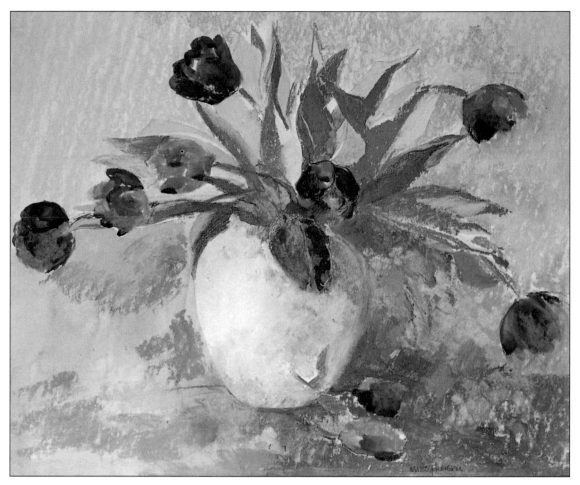

ABOVE This study of tulips by Norma Stephenson is executed in pastel and watercolor on board. Here the media are perfectly employed to provide a well-balanced picture, both in design and color.

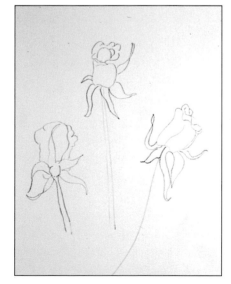

ABOVE Three one-minute studies of a rosebud by Pat Broomhead. Something like a 5B pencil is ideal for these exercises as it gives a soft, dark line.

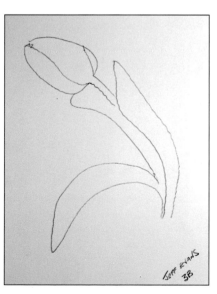

ABOVE The very wavy, almost jagged, line well demonstrates the tension experienced by Jeffrey Hopkin Evans when first attempting a minute study.

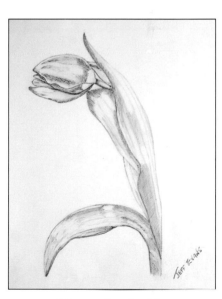

ABOVE This pencil study of the same tulip by Jeffrey Hopkin Evans, completed an hour or two after the minute study, shows the difference when the work is undertaken in a relaxed, unhurried fashion.

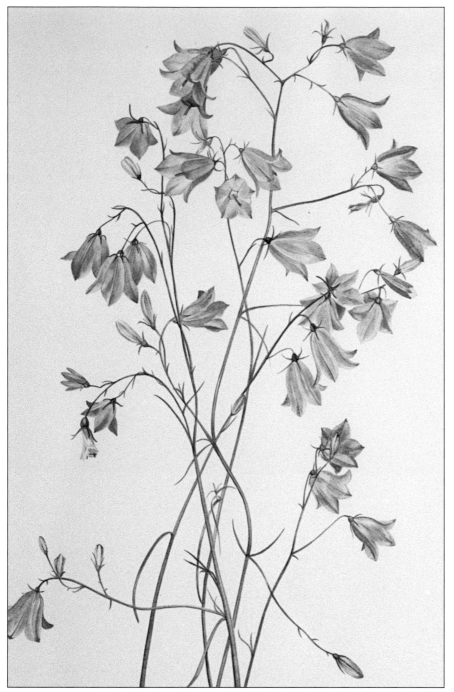

LIGHT AND SHADE

Achieving the correct balance of tone, the light and shade, is very important and without shading, no matter what medium is used, a drawing will be lifeless. First consider your light source. If the principle source is from the left, highlights will fall mainly on the left and the darkest area will be on the right. Any shadows cast by the subject will also be on the right. Such shadows cast, say by one leaf onto another, lower leaf, or by one petal onto another petal, help to give substance to the drawing. When a viewer looks at a painting and says that they feel they can touch the flower, pick it or even squeeze it in the case of a beautifully cupped rose, what they are recognizing is that substance.

In order to quickly recognize and convey the density of shadow and, most important, the highlights which lift the drawing, you will find it helpful to practice a few exercises. Using either a very soft black pencil, 4B, or fusain, charcoal pencil, get into the habit of doing a quick leaf study when opportunity permits. Glossy leaves such as camellias, holly, some rhododendrons, and some ivies are all ideal for this. Then if you choose to paint in watercolor your eye will better recognize those areas of special interest.

Some of the more delicate flowers, snowdrops for example, require very delicate shading, and you should make sure you choose the right drawing medium. A charcoal snowdrop loses its beauty; it needs a gentler medium. The choice of drawing medium appropriate to the subject is always vitally important, and the wrong choice can change the very nature of the flower. Shading also allows you

unattractive. We will be returning to this subject later in the chapter on Composition and Layout on page 35. The basic rule is to follow the natural growth of any subject and not attempt to change it unless you are working purely for design, when you may take more liberties.

With wildflowers such as harebells, or *Campanula rotundifolia* to give them their proper name, delicacy of petal combined with

ABOVE **A simple flower such as the harebell is best depicted in a straightforward manner, uncluttered and relying on the beauty of line and color to speak for it. This drawing is by Margaret Stevens.**

slender yet strong stems enable the artist to depict the flowers so that you can almost feel the wind blowing over the hill, just by the angle and rhythm of the lines.

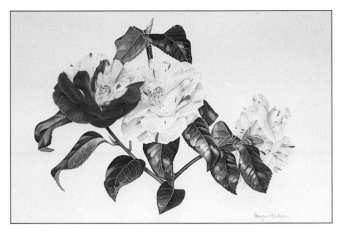

ABOVE A rough exercise by Margaret Stevens using conté charcoal on Ingres paper to practice highlighting glossy leaves such as those of these camellias.

ABOVE RIGHT However beautiful the flower may be, as with this camellia "Cheerio" by Margaret Stevens, it is the leaves which are necessary to show the bloom off to its best advantage. As much

care should be given to their depiction as to the petals. Too often a good flower study is spoilt by the sloppy treatment accorded to the leaves.

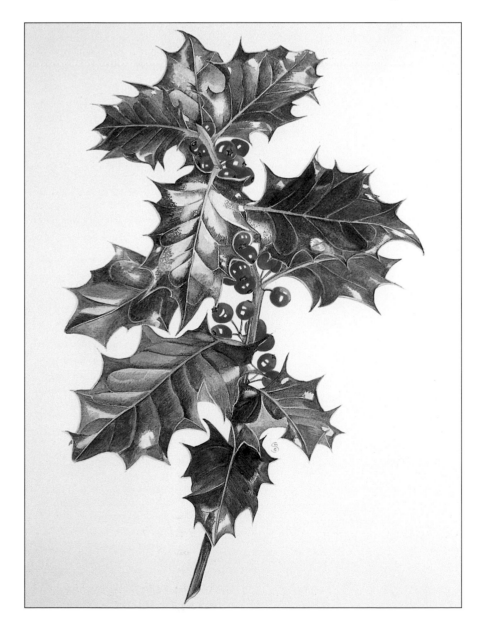

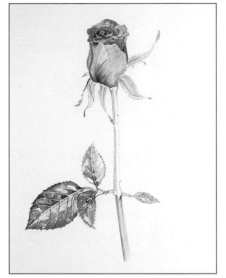

ABOVE This study of a rose by Pat Broomhead using HB, B and 3B pencils with the addition of red crayon illustrates how the combination of dark shading and even a little strong color changes the classic emblem of love to one that conveys a slight air of menace. This emphasizes the need to select the medium with care in order not to alter the character of a flower.

LEFT The holly leaf allows the artist (Margaret Stevens) to use the brush as a drawing instrument in order to reproduce veins and stomata, the tiny stippled cell structure apparent in areas of high gloss.

to show depth in a very obvious way. In the case of a nearly full-blown tulip it is not too difficult to draw the curved circle of petals with the central pistil, but only by shading will the viewer be able to imagine a bee flying into it.

Fruit, too, needs accurate shading, and never more so than with the common blackberry. Each little pip is likely to reflect the light in its own way, while shadows on the dark side give realistic roundness without which it would lack form. A common error with a blackberry, is to show the "white" highlights on each pip without any variation in position. The effect is to create a polka-dotted fruit and indicates that the artist has not really studied the subject. If you look at a blackberry you will see that each pip reflects the light slightly differently. Grapes always appeal to the student and an art course rarely ends without the call for a demonstration from the tutor on how to show the elusive "bloom". Even those who have seen it many times before are still intrigued. As with each of the subjects mentioned, there is no substitute for observation and practice. Keep a sketchbook or even scrap paper handy and try not to miss an opportunity to draw, even a few lines.

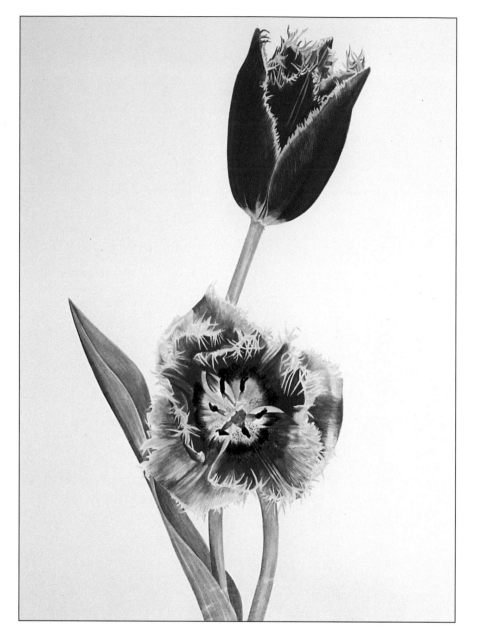

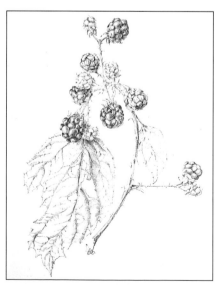

ABOVE This botanical drawing of a tulip named after the printer who was responsible for one of the first printed herbals, Johann Gutenberg, shows how the brush is used to line the petal, conveying both curve and texture.

LEFT This exquisite study of a blackberry spray by Brenda Benjamin captures the curving growth line of the stem and the droop of a ragged leaf. Note also the care exercised in the shading of each blackberry seed. The highlights have been well observed and the shading in general conveys that some of the berries are still unripe.

COMPOSITION AND LAYOUT

Composition is the key which makes the difference between a drawing that is a visual delight and a piece of work that will not encourage a second glance. No matter how well executed, if the subject is badly set out or unbalanced in design it loses its visual appeal. Just occasionally you may see an 18th-century painting in which a pineapple is poised high above a vase of flowers, instead of adding its weight more naturally at the bottom of the composition, but this should be treated as the exception, rather than the rule.

PLANNING THE WHOLE

At the most basic level layout is the ability to place a single subject correctly on the paper. When this goes wrong it is usually due to lack of observation right at the start of the work. It is far from unusual for beginners to "run out of paper" by concentrating on that aspect of the subject that is nearest to them without giving much thought to another section, which they presume to be less important, but which still forms an integral part of the whole. So before starting your drawing, make sure that you have allowed enough room for all that you wish to show. That includes a length of stem long enough to balance the flower head. Particular instances are large subjects such as the mop-headed or lacecap hydrangeas, which although they grow from the joint on a comparatively short stem, require a sufficient length, with leaves, to make a good portrait. Think also of a lupin or a delphinium. It is surprising how often the beginner starts to work on one of these using a piece of paper which is virtually square, so that you are likely to "run out of paper" while still on the flower spike, let alone the stem. So the first rule should be to select a sheet of paper or other support of size and shape suitable for the subject.

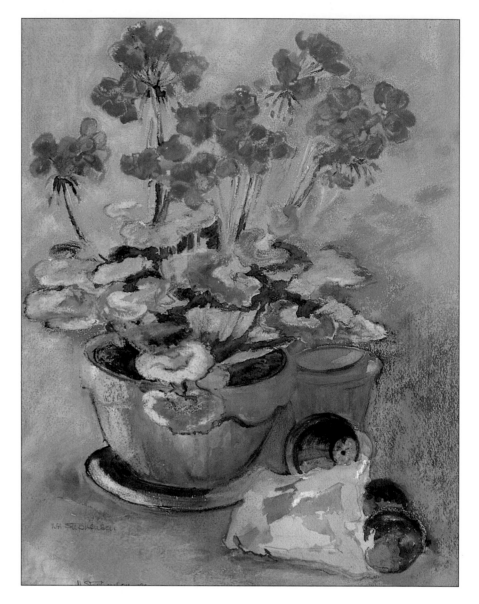

ABOVE RIGHT **A pastel and watercolor study by Norma Stephenson on a NOT paper. The use of a "slatey" background allows the warmth of both geraniums and terracotta pots to dominate.**

RIGHT **A stippled drawing by Aino Jacevicius of a lacecap hydrangea which is balanced and nicely angled on the paper.**

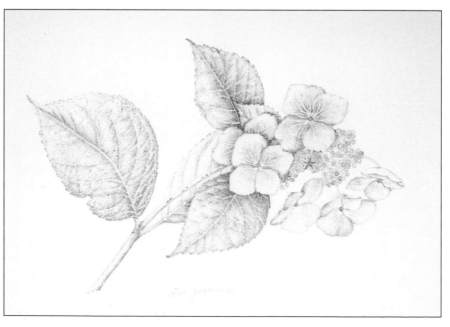

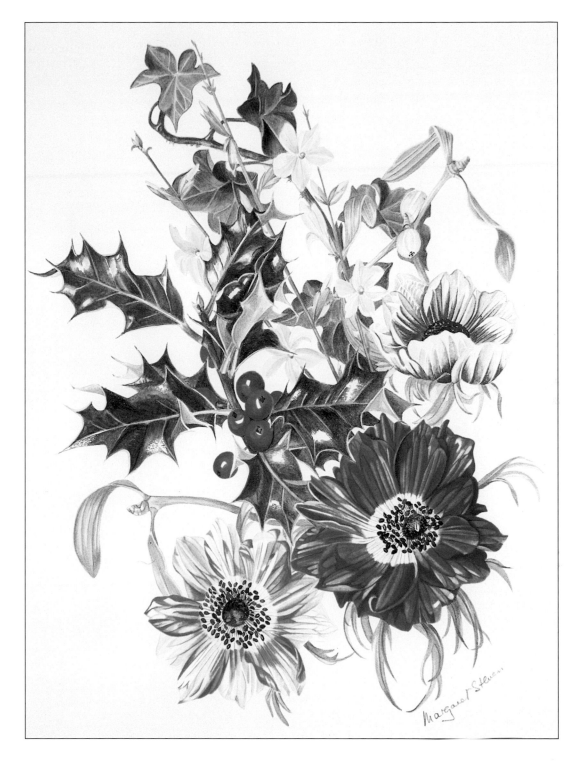

For a more complicated study, using a variety of flowers with their attendant diversity of form, certain basic rules apply, regardless of the media employed. It is doubtful if such a piece of work would be in monochrome and is more likely to be a pastel or watercolor drawing. If you follow a simple slogan borrowed from the flower arrangers, you will find it helpful – "Three, five and seven with one for the parson". This means that if you work with odd numbers of flowers or sprays of foliage the arrangement will build up into a more natural and harmonious design. Curves and triangles are more pleasing to the

ABOVE A balanced composition of anemones and winter jasmine by Margaret Stevens roughly following the odd number rule. Note that small sprigs of winter jasmine look fine in this context but if portrayed alone against their natural line of growth and in any great quantity, it is another story. The brush is used to draw the filaments of stamens in the anemones, and to work the veins on the petals.

ABOVE **A numbered diagram to show the composition layout and sequence of work for this mixed summer flower arrangement by Margaret Stevens: (1) lily – the first perfect flower; (2) dark blue delphinium giving instant depth; (3) rose "Aloah" – a bright warm central heart, below the halfway line; (4) rose "New Dawn" to take the eye down as a balance to the lilies; (5) to the top with a mauve Canterbury bell; (6), (7) and (8) pale blue aquilegias balancing both sides of the composition; (9) one white Canterbury bell; (10) pale pink Canterbury bell; (11) another pale blue aquilegia to carry the blue theme round the outer edge; (12), (13) and (14) honeysuckle to lighten the bottom line. Leaves and stems are added when you are sure that neither, but particularly stems, will block your options and prevent a useful addition to the composition.**

eye than squares or straight lines, few of which are found in nature. "One for the parson" refers to the practice observed by church flower arrangers, who tend to put the main focus of the display facing towards the congregation. Unless a few flowers are placed at the back of the arrangement the parson, from the sanctuary, sees nothing but greenery, and not necessarily the best of that.

So it is with a flower arrangement on paper. A composition where all the flowers face the front, without some in profile or semi-profile, is flat and uninteresting. It is even better to show the back view of one or two flowers, suggesting that it is a three-dimensional arrangement. Some of the taller subjects, Canterbury bells for instance, have flowers which spiral up the stem, making it easier to convey depth.

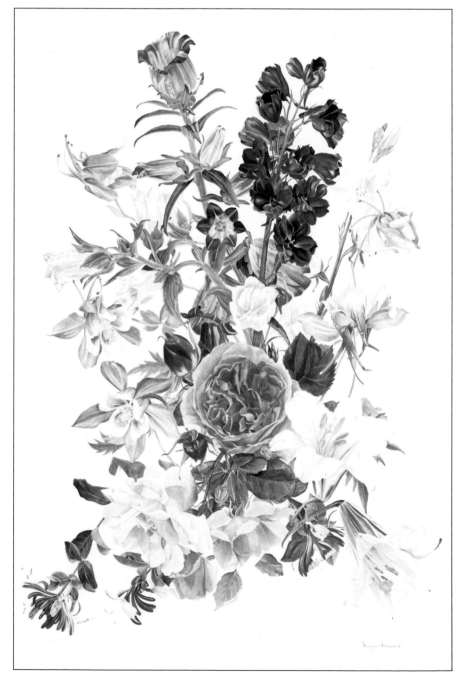

RIGHT **The completed mixed flower study, "Summer Glory". (Reproduced by courtesy of Felix Rosenstiels Widow & Son Ltd.)**

CONSIDERING COLOR

When selecting flowers their color needs consideration. It is, for example, unwise to place white flowers in the center of an arrangement. Seen from across a room they will give the appearance of a hole through the center of the picture. Blue flowers are useful because, as blue is a cool color, they will recede and this too is helpful in conveying depth. In a mixed arrangement larger subjects are best kept in the bottom half of the composition, to give weight and solidity to the overall design. This does not mean that lighter weight flowers cannot be brought down to soften the line and prevent the piece from becoming too "sturdy". The natural growth of the branch or stem will dictate its best position in the arrangement and you should not force any flower into an unnatural line.

Look on the creation of this kind of mixed flower picture as flower arranging on paper, whether it is composed from sketchbook studies or from fresh flowers. It is that latter aspect that concerns us now.

ABOVE RIGHT This study of hibiscus by Valerie Wright is a good example of a composition based on the natural growth of the subject. Take note of the flower in the corner – this is very necessary to emphasize the focal point from which the shoots emerge.

RIGHT A charming study of winter anemones by Norma Stephenson created by the use of pastel on top of watercolor. The tooth of the paper is used to fine effect in the background.

DRAWING IN STAGES

The impressionist, freestyle artist who works quickly has a much easier time than the artist working in the traditional naturalistic style. The former has a reasonable chance that the picture will be completed before the flowers have died. Not so the more botanically minded artist whose work can take days if not weeks. However, there is an approach that many artists find most rewarding and ultimately the easiest way of solving the problem.

Let us assume that you go into the garden and find the perfect flower. Far better than picking a huge bunch, which will surely die too soon, take your perfect flower indoors and put it into water quickly. Choose your favorite paper, look at your flower and use your imagination. Try to visualize the sort of picture you want to create. Use scrap paper if it helps and note down some rough ideas based on your one perfect flower. With care you will choose the right position, then draw it in, making sure that when you come to paint it you will not block your options. This means that all the time you are working in pencil you can erase and place one flower, or leaf, *in front* of another one.

Once watercolor is added that option is removed. For that reason it is wise only to indicate the position of stems in pencil until you are certain they will not, for example, cut your composition in half. It may be possible to paint from bloom to first leaf joint but no further. Having completed the first flower to your satisfaction you will be able to select the next one and decide where that is best placed. So the whole composition builds up, the position of each flower based on its color and shape, and following, but not *too* rigidly, the odd number rule and the use of triangles and curves.

MIXED FLOWERS

M A R G A R E T S T E V E N S

A flower study that aims for botanical realism cannot be quickly achieved and requires a different approach from that of the freestyle artist. This study, using artists' watercolor paints on Arches 140lb (300gsm) paper, demonstrates dry-brush technique, in which much of the detail depends on brush drawing.

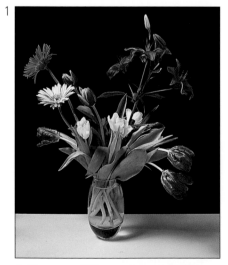

1 The vase of lilies, gerbera and tulips shows the raw material from which this picture evolved.

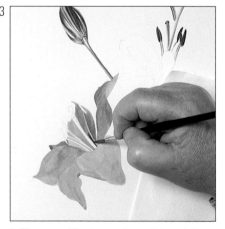

2 A pencil drawing of a lily was followed by work on the bud, before it opened and spoilt the composition. Washes of color are built up from palest yellow to deepest brick red.

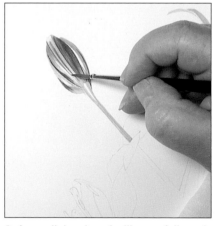

3 The open lily shows the artist applying color, using a size 2 brush, around the stamens. Already you can see how the different elements of the composition are beginning to relate to each other.

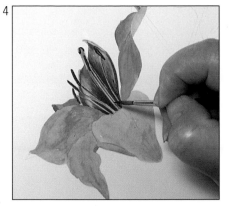

4 More detail is being added in this tricky central area of the flower.

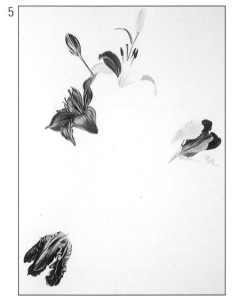

5 Two tulips are added to give the outline triangular composition.

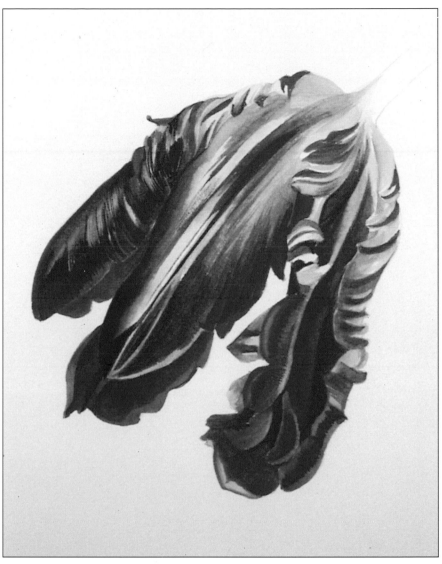

6 A close-up of one tulip, worked up as always from palest yellow and green to richest "feathers" of crimson, doing full justice to the texture of the petals.

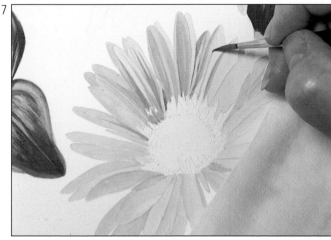

7 A golden gerbera is added in the top half of the picture and the petals are molded with the brush using a mix of yellows and brown madder on a base of Naples yellow.

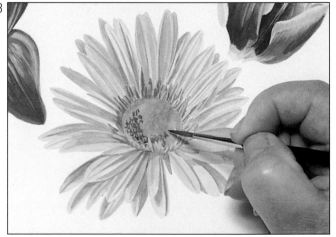

8 The complicated center is worked up with the brush, using dark brown with a hint of purple to give intensity.

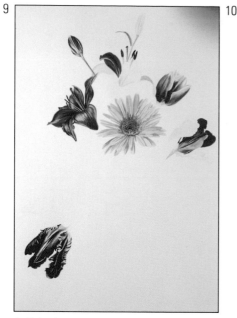

9

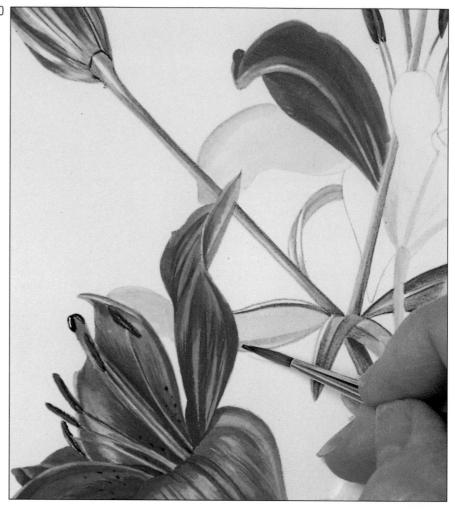

10

9 This shows the composition so far. The next stage will involve adding stems to add structure to the whole.

10 The artist now adds leaves and stems at the top of the picture.

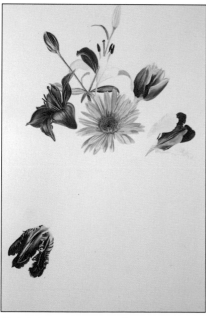

11

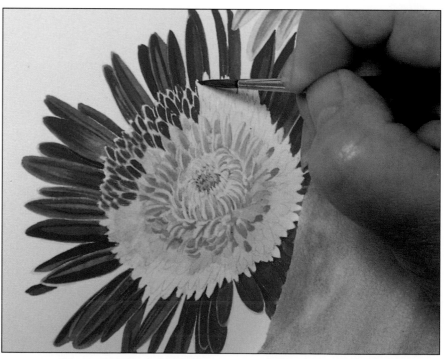

12

11 It is important to see that no stems have been carried into the lower half of the picture, thereby enabling the artist to leave her options open.

12 A red gerbera is painted, slightly to the back of the golden one. An all-over yellow wash at the center is built up with the brush to show the many tiny petals.

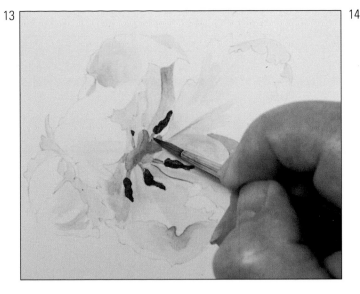

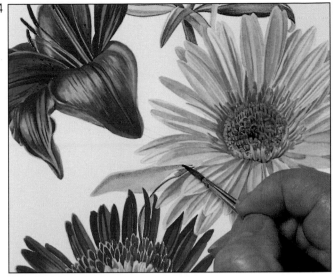

13 A full-blown tulip enables the artist to portray the stamens, using a brown/purple mix for the very dark tone.

14 More leaves are added to give a sense of depth.

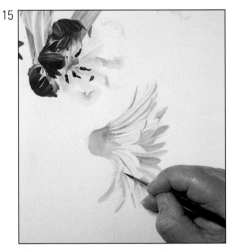

15 Another golden gerbera, this time in semi-profile, balances the composition.

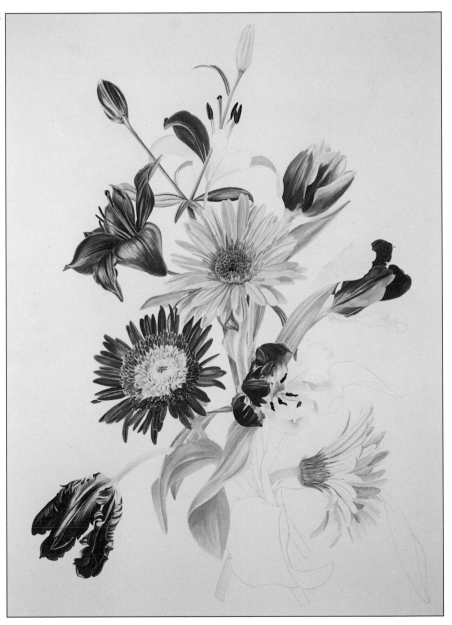

16 Almost finished, the study gives an idea of the artist's ultimate intention regarding composition and blend of strong colors.

OVERALL EFFECT

In any work of this type, which is decorative and not botanically correct in the strictest sense of the word, it is not always wise to copy slavishly the lines of, say, a spray of foliage. Altering the angle of a stem or the juxtaposition of leaves can make all the difference between muddle and a satisfactory picture. Aim to achieve balance of line and harmony of color that will please the eye, and you will have a good composition.

It is worth mentioning that you should consider carefully which varieties of flowers make good bedfellows. A good example occurs in Spring when narcissi and daffodils bloom in the grass, backed by flowering shrubs such as camellias. This sight is not uncommon in larger gardens or parks and never fails to give pleasure. If, however, you combine daffodils and camellias in a painting the result will not be very satisfactory. This means that certain subjects need space to be appreciated, as if they are good friends who nevertheless cannot live together.

Some flowers do not look right if portrayed as cut flowers. A bunch of snowdrops looks good, but never a bunch of crocuses, which looks unnatural. Many smaller bulbs and plants look best when shown growing naturally, either in a pot or in the ground.

The dedicated flower portraitist will always be using his or her powers of observation, so that a walk in any garden will result in some new idea being tucked away in the mind for future reference. It may be a combination of colors, or just as likely the grouping of different foliage plants in a border. Try to cultivate that kind of eye, which will make it easier to transfer a visual delight to paper.

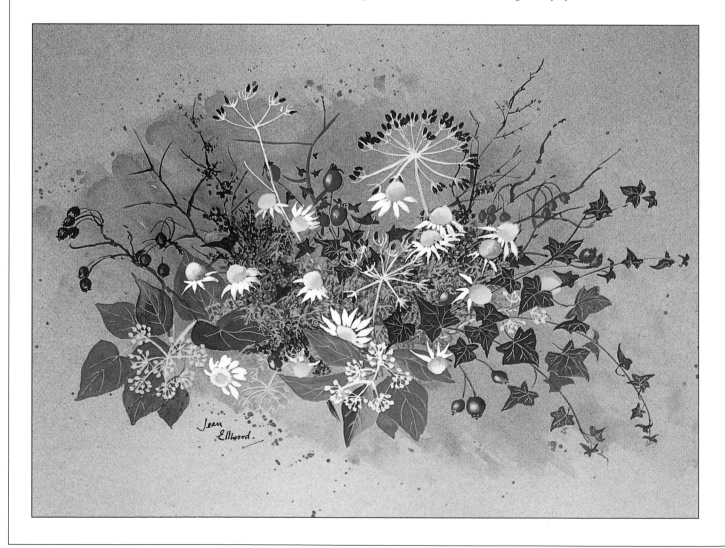

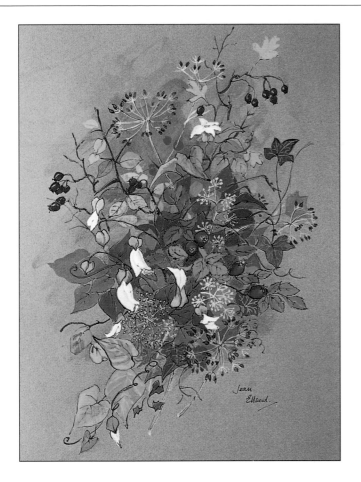

OPPOSITE AND ABOVE LEFT
Two examples of free studies by Jean Elwood using gouache, and ink, on Ingres paper, which capture the tangled growth of the hedgerow.

ABOVE RIGHT *Camellia japonica* "Melody Lane" is a fine sight, like all camellias, when portrayed on its own, but suffers if combined with other spring flowers such as narcissi. It is a plant which likes to be alone when committed to paper. Drawing by Margaret Stevens.

RIGHT A pastel, watercolor and watercolor pencil combination of cyclamen by Norma Stephenson on rough watercolor paper. The angular treatment of the leaves lends an abstract quality to the whole.

USING A SKETCHBOOK

Using a sketchbook is one of the most valuable of all exercises. Not only will it encourage spontaneous and fluid drawings but its use will aid confidence. Even a child who shows an interest in drawing benefits from a book and pencils bought especially for the purpose. He or she will see it as something special, rather than as an important scribble.

There are many occasions when working in the field that the artist cannot function without a sketchbook. Gone are the days when you could pick a few flowers and bring them home to draw and paint at leisure. Now there are legal obstacles to prevent such an act. Most of us who love flowers can tell of the field in which, forty years ago, we gathered posies of white violets

from beneath the bank, now lost beneath modern housing.

Without a sketchbook many wildflowers would be denied to the artist. How else will you record the bee orchid or some other delight now a rare sight? For that reason alone it is worth keeping a sketchbook, and it is up to us to play our part in conserving those plants that are left for our successors by sketching rather than picking them.

The sketchbook may be kept for its own sake, as a way of recording a passing moment, or as an aid to creating a more formal picture. It is sometimes the case that something catches the eye when there is not enough time to spare in which to do it full justice. By quickly drawing it and making color notes you will have it on record for use in future compositions.

BELOW A library page used to record a collection of wildflowers native to California in the University of Berkeley Botanical Gardens, San Francisco, by Ann Thomas. All the work was done in the field using pencil and Rotring Artist Color Ink. The advantage of using ink in this way is that no water is needed and it captures the translucency of the petals. The disadvantage is that it is quick drying in the hot sun. The artist writes: "It is difficult to keep paper clean outside, but the compensations are many; humming birds visiting the leopard lily, tiny fluffy golf ball-size quail running for cover and bald eagles soaring overhead."

OPPOSITE ABOVE LEFT, RIGHT AND BELOW LEFT These three pages from a conservation sketchbook by Dolly Norledge record wild plants growing at Norland Spit on the Isle of Wight.

OPPOSITE BELOW RIGHT This sketchbook page by Ann Thomas shows the flora and fauna of a sand dune system in Wales.

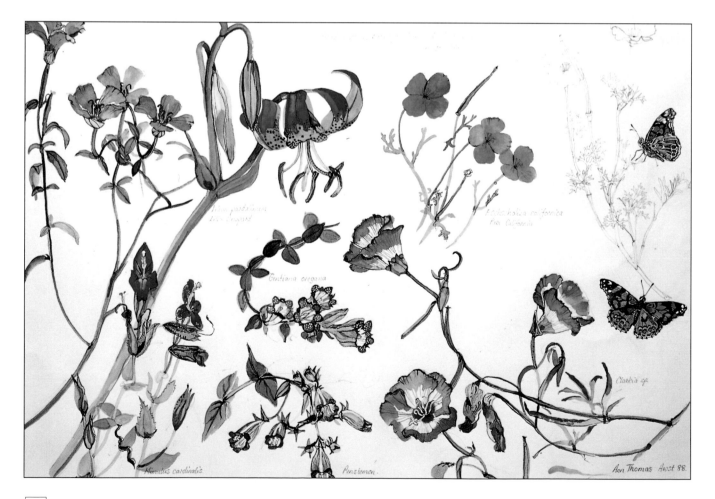

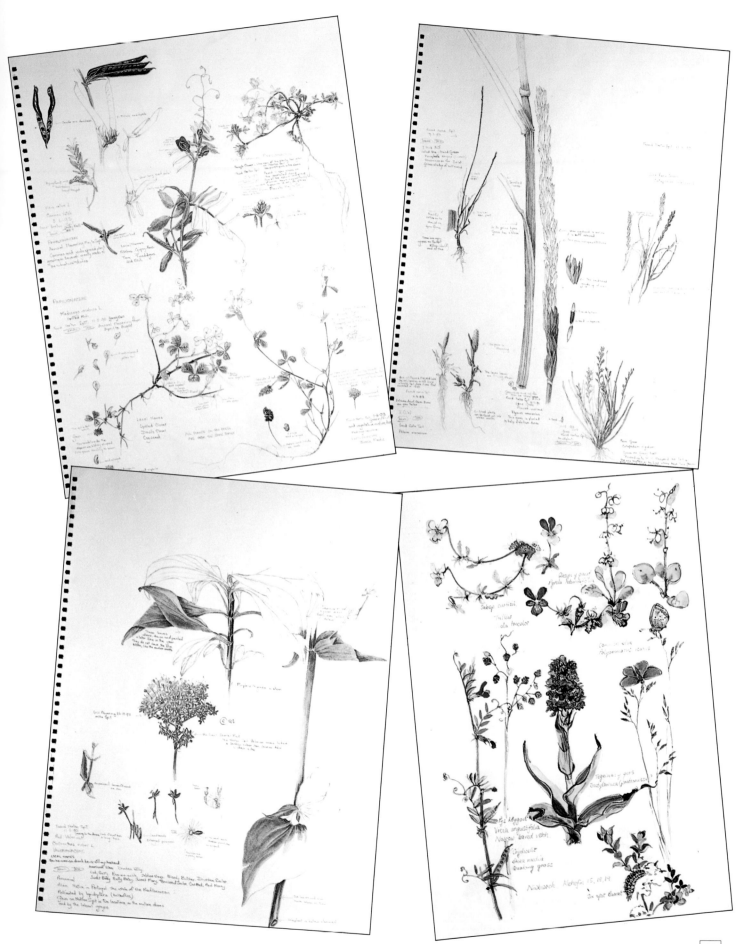

When you wish to transfer the image you may choose to copy it freehand or use layout paper or tracing paper to help you to make a good composition. You can move tracing paper around over the various images you wish to transfer until you find the most satisfactory composition. This method enables you to take your time and can lead to some very pleasing pictures.

RIGHT **A library page by Kay Rees-Davis showing various studies of the common poppy. Notice the brush drawing which has helped to achieve the crumpled tissue paper effect on the petals, and also the delicate hairs and stamens.**

BELOW RIGHT **In this sketchbook study of a scabious Hilda Lloyd recognizes the value of trying to capture the single flower which caught her eye. In this case the "frilly" scabious is accentuated by the simplicity of the grass.**

BELOW LEFT **This study of the cut leaf maple, *Acer dissectum* var. *spectabilis*, by Margaret Stevens, portrays its progress through the seasons, from the buds of early spring to autumnal fruiting maturity and on to the barrenness of winter. Pencil best conveys the serpentine nature of the multi-stemmed trunk of this ancient specimen.**

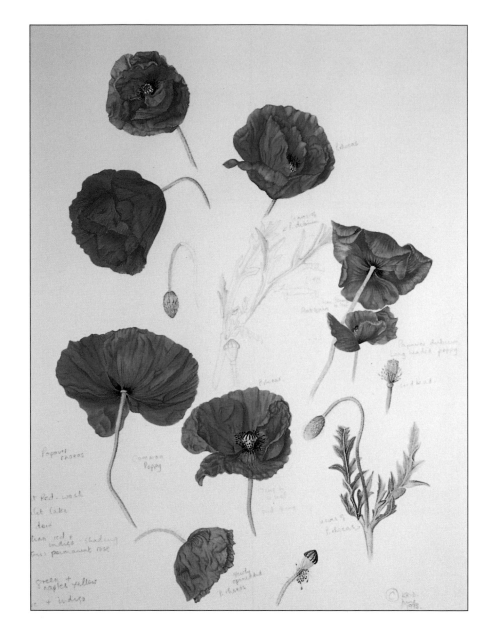

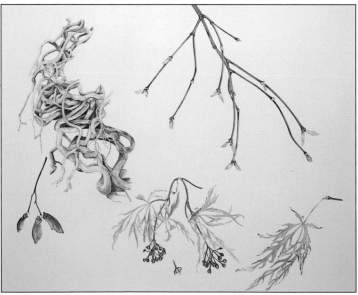

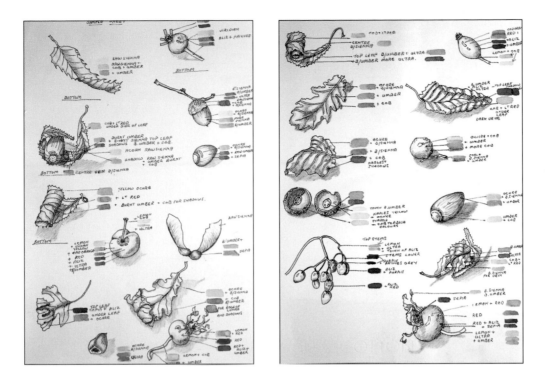

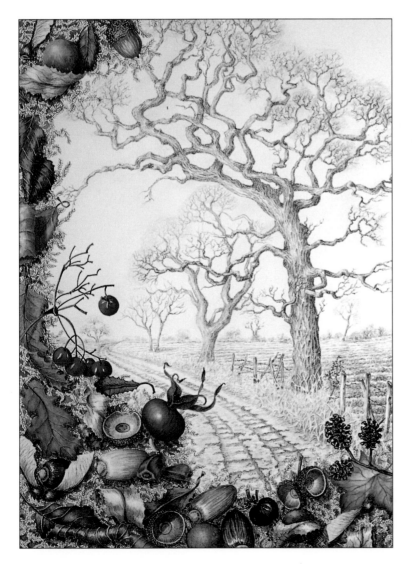

ABOVE **Sheila Scales admits to a fascination with the colors of fall since childhood. These two library pages confirm this and are an excellent example of ink and pencil drawing with accurate color notes.**

LEFT **From her drawing and color notes Sheila Scales can build up an evocative picture of fall for this *Autumn Country Walk*, using the warm richly colored leaves and berries to surround the delicate drawing of a country scene. This is drawn first, then transferred by tracing or graphite paper onto Hot Pressed watercolor paper. Working either from freshly gathered material or, when that is no longer available, from her notes, the seeds, leaves and berries are added. Finally the moss is painted in, starting with the palest green brush drawing, which is then emphasized by darker green shadows.**

The more formal version of a sketchbook study is the library page. This is typically used when you wish to combine, say, different varieties of a fruit and its blossom. Obviously the blossom occurs many weeks before the fruit, so you need to record that, accurately, when it is available. When the fruit is mature it can either be added to the first sheet, shown alongside its appropriate blossom, or recorded separately.

This same technique is valuable for noting many subjects where there is a delay before the full story is told – for example, new foliage recorded as it emerges from the bud and again months later when it is dressed in autumn colors, and seedheads too, following flowers, or bulbs before they are planted and later their blooming and root development.

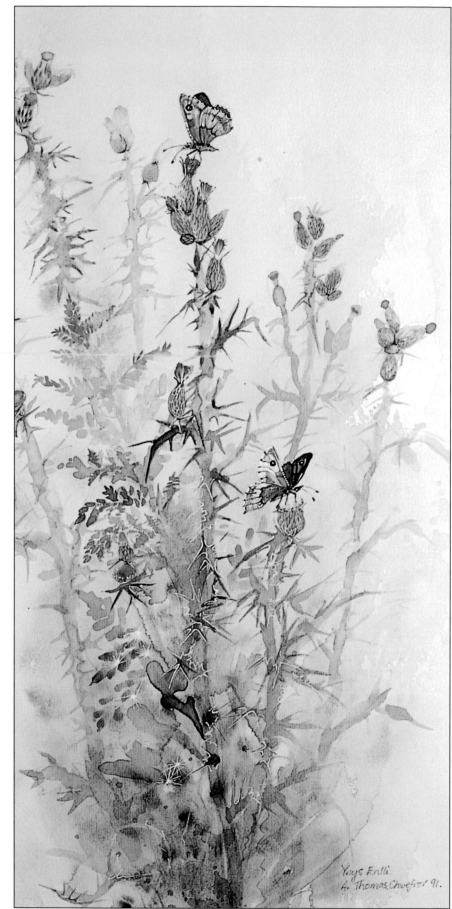

INK TECHNIQUES

"A dot can go anywhere, but a line has to go somewhere". To those who do not normally use ink techniques, the thought of a blank piece of paper, and some very black ink can seem a terrifying prospect. There seems to be no room for maneuver or error, and the result is that people shy away from it, calling ink a "difficult medium".

MATERIALS

Paper and supports

In fact, with modern equipment, and plenty of inexpensive paper, this does not have to be the case. Paper for drawing with inks needs to have a smooth surface (unless you are aiming for a broken line), but it does not need to be of the highest quality, even though you will naturally aspire to the best illustration board! Cartridge paper will do very nicely for plain line drawings, but beware! – If you wish to add a wash, or even think of this as a possibility, do use a heavier paper, and head for the ivorex board or a 90lb (185gsm) or 140lb (300gsm) watercolor paper.

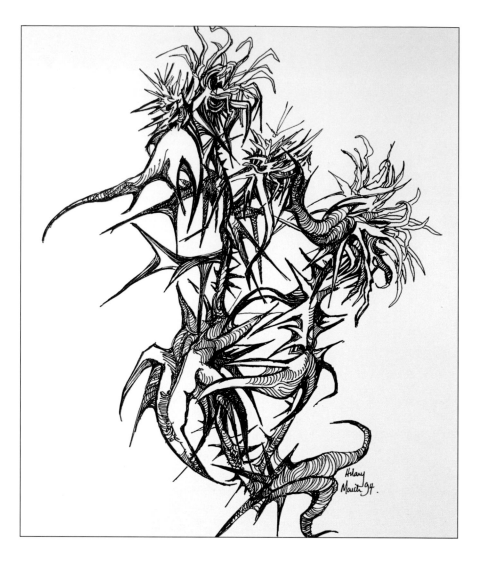

RIGHT This drawing of a thistle by Hilary Leigh shows how lines can be extended to create a sense of movement which still pertains to the plant while not being a photographic representation. Worked with a mechanical fiber-tip pen.

Pens

When it comes to pens, the choice is infinitely more varied, as you can see from the chapter on Materials on page 10. You have to experiment to find out what will suit you. Originally, fine penwork was confined to the use of the mapping pen, which is dipped in ink, the ink being held in its reservoir by surface tension. The nib scratches the surface of the paper and lets the ink onto the paper by pressure. The resulting line will often be scratchy, and sometimes the ink has a tendency to blob, but you can get a very variable line, and, because the pen is so easy to clean, you can use any ink that you desire.

However, for today's artist there are far more relaxed ways of working.

By the 1960s the mapping pen was being superseded by technical pens with tubular nibs. These pens have refillable cartridges to hold the ink, and the fine valve system provides an even flow of ink, while the nibs can be purchased in a variety of different line widths. The width of line is uniform, and extremely clean. Therefore these pens are the delight of designers and architects. On the debit side, if they are left, the pens have a hideous tendency to become totally blocked. You can spend hours soaking them, washing them out, and generally attempting to clear the valves. Also take note – *never*

attempt to use an ink that is not recommended. These pens will cease to function if you use the waterproof inks that are available for mapping pens!

For some artists the new fiber-tip pens are a godsend, seen as the successors to the tubular nibbed pens. As a throwaway item, manufactured to be readily available, you are limited to using the colors which are equivalent to ballpoint pen colors. Even so, they do have the advantage of being waterproof and light resistant. In addition to this, being fiber tips, the pens do not carve up the paper, and the flow of ink is guaranteed, until the pen gives up the ghost.

BROOM

M A R G A R E T S T E V E N S

A very simple line and wash drawing, with later additions using colored and
watersoluble pencils.

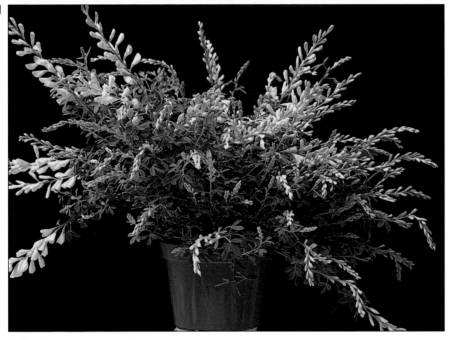

1 A pot of broom suggests summer on a
February day.

2 A single flowering spray is very quickly
drawn using a 0.3mm technical pen.

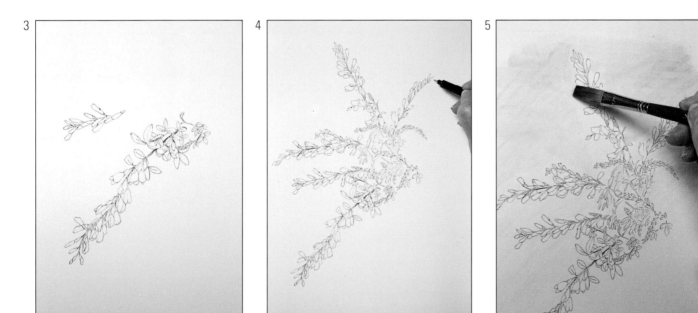

3 As it is not intended to portray the
entire plant, a second spray most suited to
its position is added.

4 The desired shape of the composition is
gradually achieved.

5 The artist adds a pale wash of blue
watercolor behind the blooms.

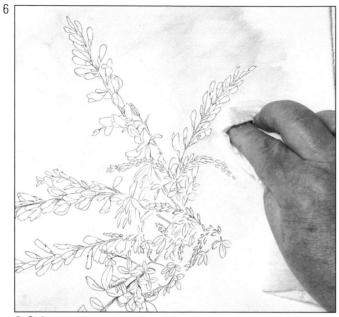

6 Soft paper towel is used to dab out a cloud effect.

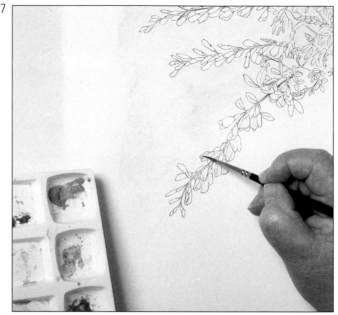

7 A wash of pale aureolin yellow is applied to the flowers with a little Indian yellow to provide simple shading.

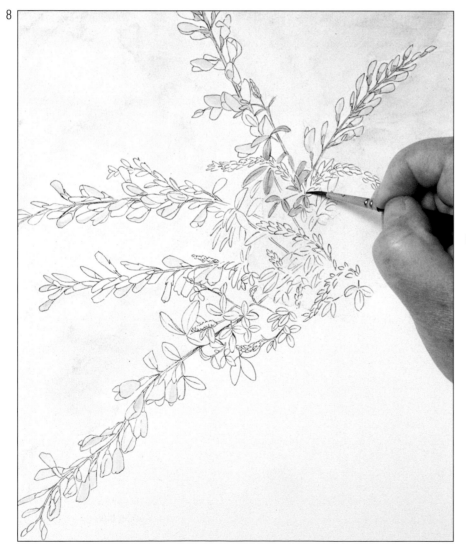

8 The tiny leaves are washed over with a pale bluish-green.

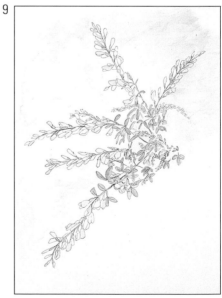

9 You can now see the overall effect.

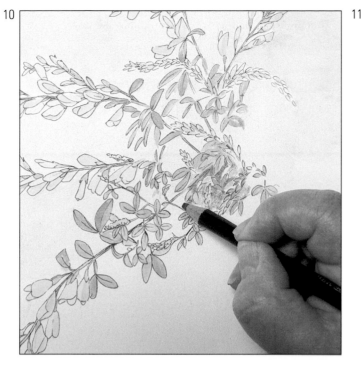

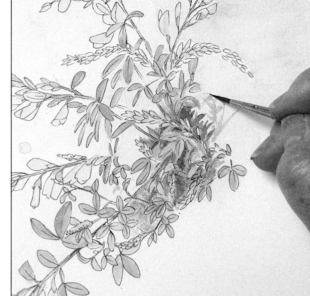

10 The artist uses a watercolor pencil in night green to give depth at the base of the plant.

11 This deep color is blended in with water using a fine sable brush.

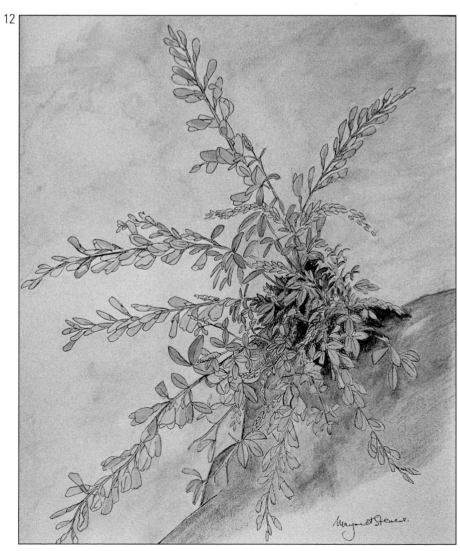

12 Later the picture is finished by the addition of a rocky outcrop executed in watercolor and colored pencils. Further sprays of broom extend the plant and additional cross-hatching in ink intensifies the shadows.

STARTING DRAWING

The major problem with pen work is that the moment you put a line on a piece of paper it seems to be there for all time, immovable and unchangeable. With pencil you can change lines, but pen lines are quite different, and permanent. Therefore you may become nervous, and this shows immediately when you start drawing.

There are three basic easy ways of overcoming this first difficulty. The first, which most people use, is to make a rough drawing in pencil before applying the pen.

The second method is to make an outline of dots, in pen, so that if you make a hash of the basic outline, you can disguise the mess more easily when it comes to adding the shading at a later stage.

The third method, which can be used quite happily in conjunction with the other two is "The Power of Positive Thought". Before you start on your main drawing, find any old sheet of paper, even photocopy paper. Look at your plant, and start to sweep in the outline, without panicking over exact proportions. Let the pen and the line do the work for you. If the line is straight, then sweep it along. If it is crinkly, then try to follow the crinkles with the pen. Try not to lift the pen from the paper too often. (Nerves often show themselves by the use of short, tentative strokes in such a drawing.) If you think that you have gone wrong, just go over that section again. Above all, concentrate on the plant and not on your drawing. Five or ten minutes later you should have

a very positive drawing, and this is the start of having enjoyment with line. You should also have a far better idea of what you wish to portray in your next drawing.

Once you have reached this far, you have to consider what type of drawing you wish to make. Do you want an accurate representation of the outline, or are you going for an impression only? Do you like the effect of scribble, or careful cross-hatching? Ask yourself all these sorts of questions. It has to be recognized that line can never be used as a photographic medium. However, it can be built up to achieve almost the same effect. So, at the stage where you are considering the outline, you must be sure of what you want to add to it, and the effect you wish to achieve.

SHADING

In terms of shading there are four easy methods of infill. The first is dots. Dots can give an infinite variety of shade. They build up slowly, and so for exact work they are ideal. Depth can slowly be added to a flower or leaf, without detracting from the outline. In the chapter on Botanical Illustration on page 103 there is a description of how to achieve the best effect using dots.

However, dots are a painstaking way of adding depth. A faster way of adding tone is to shade with line. The most exact method for line is to do contour shading. This follows the contour of the plant, either by going along the line of the plane, or else by traveling across it. On

RIGHT **An example of contour shading on a drawing of a sunflower by Hilary Leigh using a mechanical art pen.**

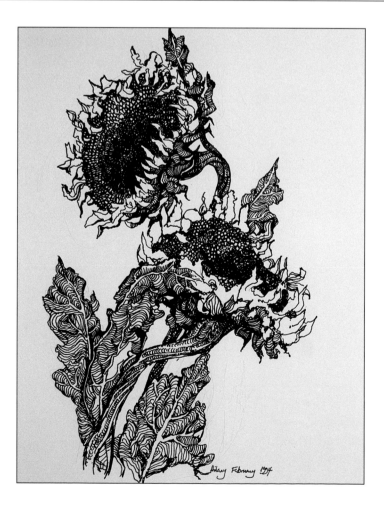

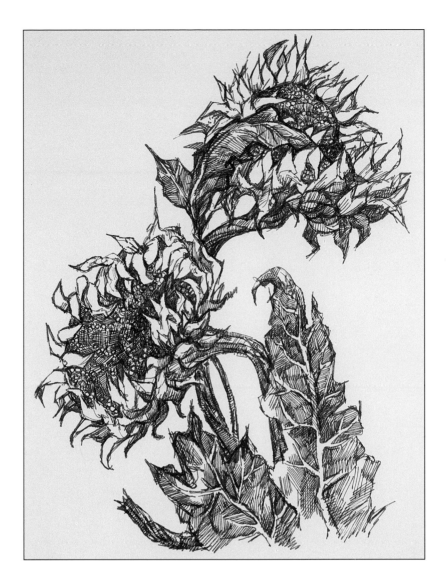

monocotyledon plants, such as grasses, or lilies, this means that your drawing will have lines that either follow the lines of the veins or else a lot of short lines that go straight across the blade of the leaf. However on dicotyledons, such as the sunflower, this can give a strange wavy effect, as the leaf will curl between the veins. Contour shading is well suited to those who enjoy solid and exact outlines, and can be effective combined with dot shading.

The third method of infill is to use straight-line shading, though this is not always appropriate – flowers do not have straight lines of shade in them. However, for artists who want to achieve an effect which is not necessarily botanical, straight-line shading is useful. Areas of straight lines, juxtaposed to one another can give a wonderful texture. This can be more appealing than traditional cross-hatching, which works better with pencil. (Cross-hatching with a pen, unless it is very fine, generally appears over-ponderous for flowers.) If you are using a mapping pen, you can give each line a slight flick, which will vary the thickness of the line, thus giving even greater variety.

The last method is – scribble! Scribble follows no general pattern. If just happens. You think, "That bit should be dark" . . . and find you have scribbled the area in. For those who love just playing with drawing, scribble is automatic. However, if you are concentrating on the flower or leaf that you are drawing, you may often find that the lines you are scribbling in are trying to echo the movement of a petal or leaf. On a sunflower leaf, for instance, you may find yourself carving a line over and over again, trying to get greater intensity into it, or, for a petal you may have produced a squiggly line which is trying to follow the feeling of the petal rather than the outline.

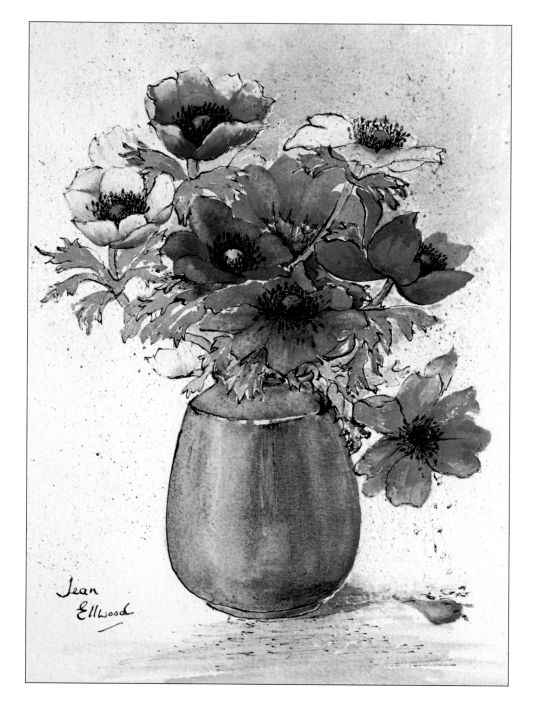

In addition to the methods of adding shading by pen, you can also add washes, either by using watercolor (thus becoming a mixed-media method) or by adding ink washes. Washes can be watered down, and applied with a brush, using a similar technique to watercolor painting. If you are doubtful of the effect this will have, start with a very light wash, and then keep adding to it. If you add ink while the wash is still very wet you can achieve lovely spidery wet-on-wet effects. You can blot washes on by whatever method you wish, using cotton-wool, or even by dabbing your finger or thumb in the wash, and using it as a stamp. The wash can also be added at any stage, over or under the penwork. So long as the ink is not watersoluble, the wash will not affect the drawing. The only exception to this is with a few

A B O V E A simple study of anemones by Jean Elwood in watercolor and ink with a spattered background. An old toothbrush is useful for this.

watersoluble felt-tip pens, where much of the line will be swamped by a wash placed over it. Even this phenomenon can be utilized to good effect, but should not be recommended, because such felt-tips are very impermanent, and tend to fade very fast.

SEEDHEADS

H I L A R Y L E I G H

This drawing illustrates what can be achieved by using colored inks with a simple mapping pen, to portray very simple plant material.

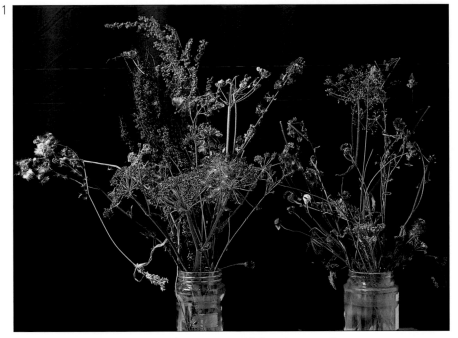

1 The seedheads were collected in summer and left to dry naturally.

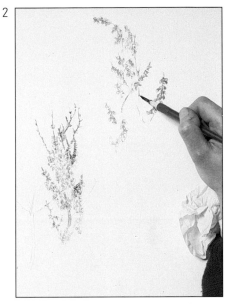

2 Two stems of dock are drawn, using burnt sienna ink, to establish the upper limits of the picture.

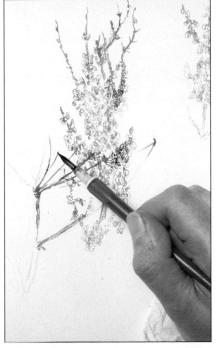

3 The artist uses purple to draw a head of cow parsley, partly in front of the dock.

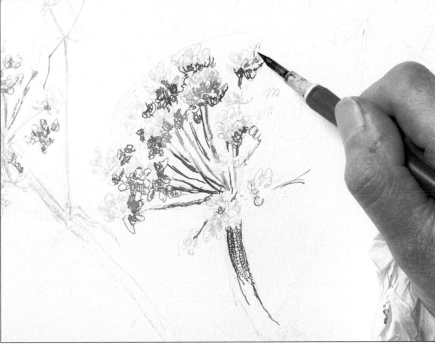

4 Purple is used again to add detail to a yellow umbelliferous seedhead.

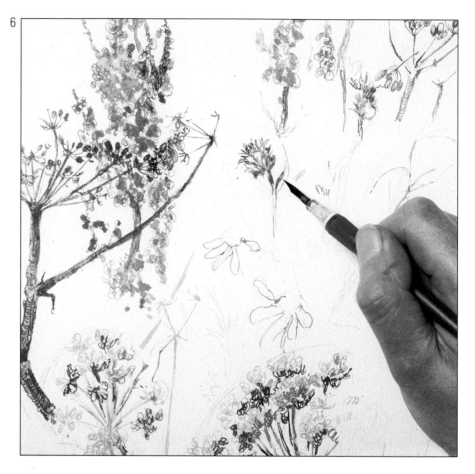

5 The basic structure of the picture is now established.

6 The artist begins to fill in the main body of the picture with further stems, but keeping to the brown, yellow and purple shades.

7 A brush is used to run in a well-diluted mix of yellow and Prussian blue, which makes an attractive green, and gives an impression of hazy depth.

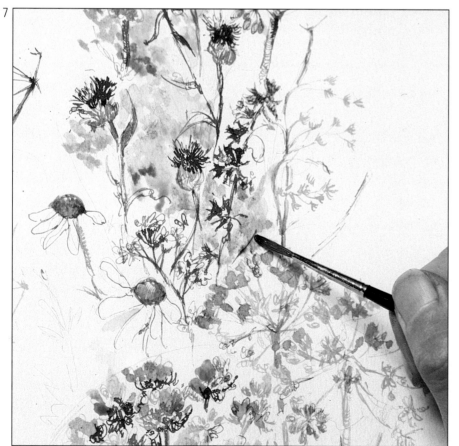

8 You can see how the body of the composition has started to fill out.

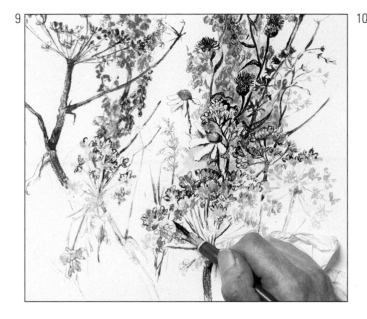

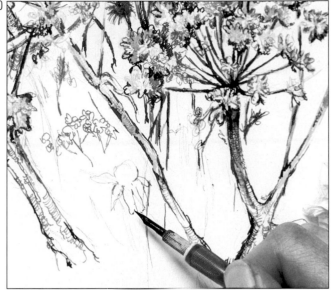

9 The artist has called on her memory of summer by including the moon daisies, and now the center of the drawing is being worked on to give a more intense tone.

10 Stems are being finished off and an additional daisy gives interest at the bottom of the picture.

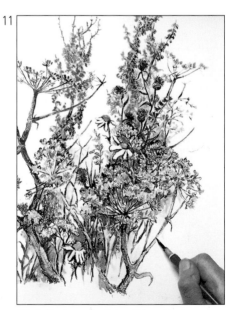

11 A final touch of detail is added to a woody stem.

12 The finished drawing is an harmonious blend of very few colors, inspired by a basic collection of what would commonly be called weeds.

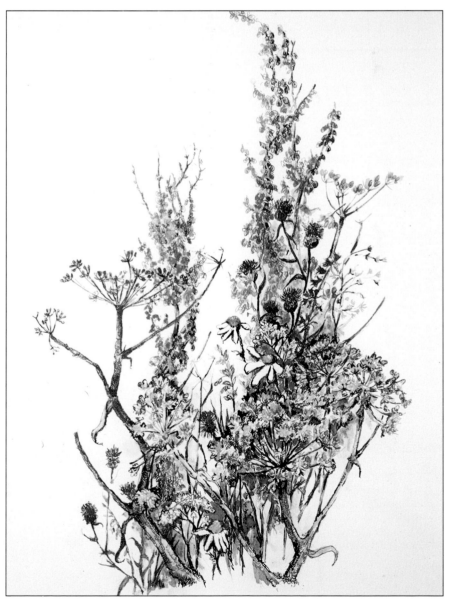

COLOR

Color, for ink drawing, has to be the choice of the artist. Traditionally, most pen drawing has been done in black or sepia. If you prefer sepia, it is as well to make sure that the sepia you use is a permanent color, otherwise you may have the shock of finding that a picture that has been exposed to daylight over a number of years, has turned into a brick red color.

If you are planning to use colored inks for drawing, take care. The inks look delightful in their bottles, and you may buy them much as a child buys candy. However, the colors are very pure and often more suited to graphics than to realistic drawing. Therefore, when you use them you have to aim for an effect rather than realism. The yellows, reds and greens may frequently be too harsh to use for

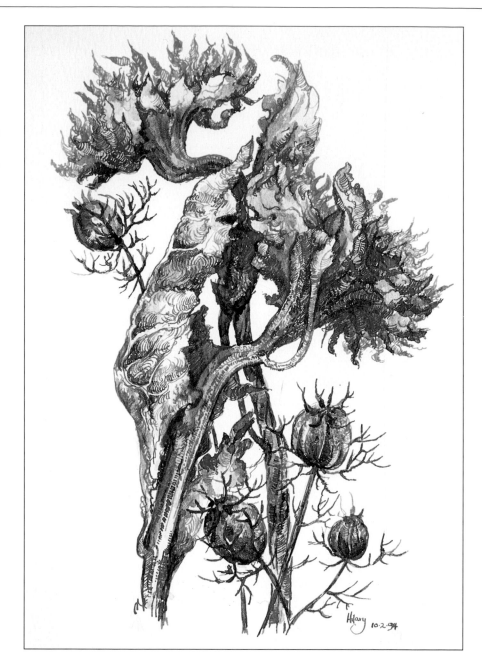

A B O V E **A good example of the effect created by mixing various colored inks in this study of dried flowers and seedheads (sunflower and love-in-a-mist) by Hilary Leigh.**

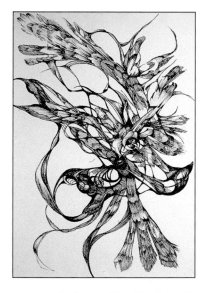

A B O V E **Perhaps ink best lends itself to the abstraction of plant subjects, as with these grasses. Ann Perry also produces some of the most finely detailed botanical studies imaginable but also enjoys working with the greater freedom of expression which abstract interpretation allows.**

flowers, though unlikely combinations can work. The surprising mixture of Prussian blue, brown and purple produces a result that is restful on the eye, and unusual mixed washes of inks are often more effective than the use of primary colors. When you are working with inks, it is handy to keep a palette handy, so that you can water down a wash, or mix inks together.

The main point to remember with pen drawing is that it is a high-contrast medium. The black is very black, the white very white, and lines are very positive. They *have* to go somewhere! So it helps to have a

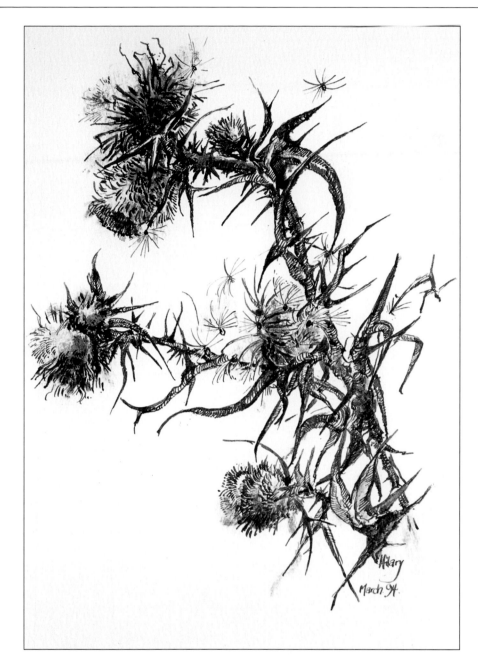

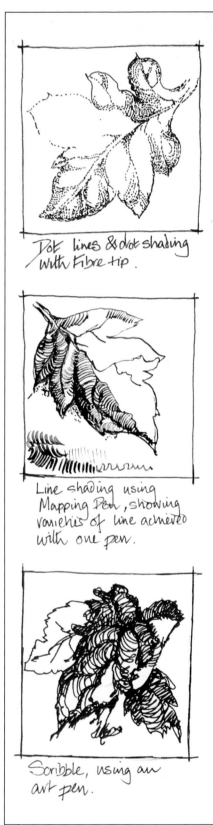

Dot lines & dot shading with Fibre tip.

Line shading using Mapping Pen, showing varieties of line achieved with one pen.

Scribble, using an art pen.

positive attitude to the lines that you are putting down on the paper. Remember the lines of Blake, "If a fool would persist in his folly, he would become wise", . . . and if you persist with a pen drawing you are likely to achieve a picture! So carry on giving depth to lines, by drawing over them, or carving around them. Fill the next bit in, with scribble, or straight-line tone. Give that leaf there some added interest, by a little

A B O V E **Drawn with a mapping pen, the effect of thistledown is achieved by dipping the thumb in a puddle of well-diluted ink and pressing it to the paper. A dusting of charcoal is added to give a "smoky" effect. Drawing by Hilary Leigh.**

contouring shading, and add a wash to the stem to give it some intensity. Eventually you will get into the habit of enjoying line as a language all of its own.

7
PASTELS

Traditionally pastels have usually been drawn on a colored ground, such an Ingres paper, which is lightfast and has a slight "tooth" to the surface, to hold the pastel. Most paints, including oils, are semi-translucent, and would therefore be affected by a colored background. Pastel, however, has a large amount of pigment in it and is opaque, so a colored but neutral ground shows up the lights and shadows to advantage, without becoming a long-term disadvantage.

PAPERS

Many modern pastel papers maintain the attractive neutral tints, but have a more marked grain than Ingres paper. They hold more pastel, but it is more difficult when it comes to rubbing pastel in, to hide the tooth of the paper. A rough (NOT or Cold-Pressed) watercolor paper will, at a pinch, work, but white does tend to be a distraction, rather than an asset. It does not give the glow that one can gain from working light pastel onto dark ground.

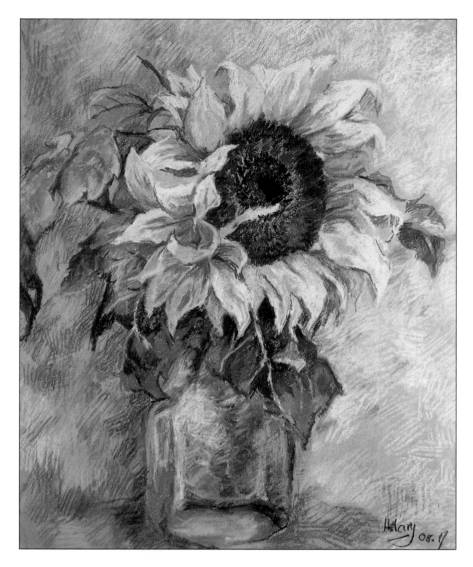

RIGHT The heavy matt color of petals and corolla are in marked contrast to the background of lightly hatched strokes in toning colors, giving the whole drawing of sunflowers by Hilary Leigh a dramatic tension in keeping with the subject matter.

OIL PASTELS

Before you decide on the base color of your paper, it is necessary to decide which variety of pastels you wish to use. Oil pastels are encouraged by the art schools, since their bright primary colors push students towards bold expression, using flat color often outlined with black. This is fine for positive constructions, but seems singularly inappropriate for flowers.

Subtle nuances are not the field of oil pastel. It is very hard to keep a sharp point on an oil pastel, and the colors have limited mixability, so their use to the flower artist is confined to the availability of a good

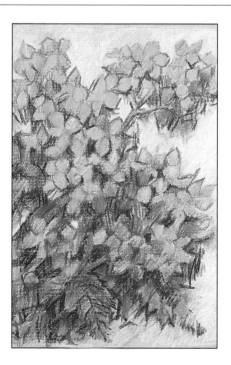

range of colors.

Nevertheless, you can create impressive effects with oil pastels by the juxtaposition of colors. This can be done either by using large blocks of color, or in miniature, to give a Seurat-like pointillistic effect. In addition it is possible to blend the colors, by plying greasestick on greasestick, or by the careful use of turpentine, which will also thin the pastel to a paint-like consistency.

LEFT A study of hydrangeas by Hilary Leigh in oil pastel on Ingres paper which creates vibrancy but little of the softness associated with pastel.

Overdrawing an area with white pastel can also produce a dimmed line, giving rise to further impressionistic effects.

It is all too easy to work oil pastels up to the point where you may feel you are working on a mud slide of raging color. At this stage it is possible to scrape away excess layers of pastel with the side of a scraper-board tool, making sure that you do not tear the paper. The disadvantage of this is that you finish up with a glazed area of paper, which will not take more than one further layer of oil pastel.

There are very few flower painters whose first love is working in oil pastel. Realism and oil pastel seem poles apart, so when you work with this medium there always tends to be a level of abstraction to it, to compensate for the diagrammatic boldness of the colors.

SOFT PASTELS

For infinite variety of color, soft pastels are the medium to use. You can make your own pastels, but most artists stick to the easy life, and buy them direct from the manufacturer. Up to eight shades for each individual color are available, and because pastels are bound with chalk you can also blend the powdery surfaces together with ease to produce more colors. The most incredible range of colors is available. Eight shades of purple-brown can be combined with eight shades of gray-green, to render the most subtle of tones. No wonder that we head for the soft pastels when it comes to flower portraits!

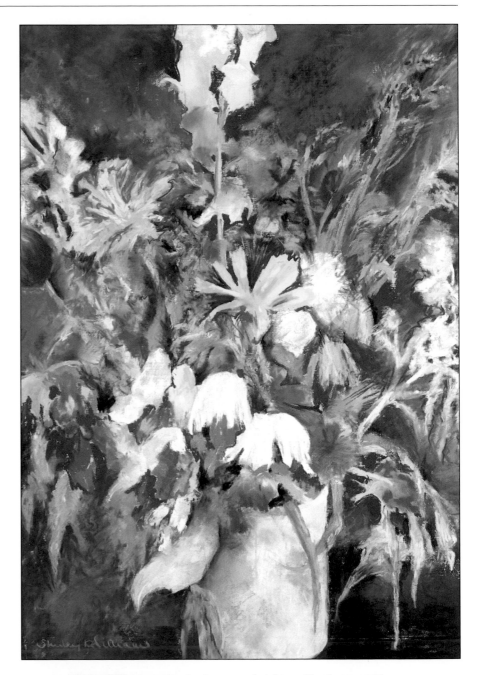

ABOVE This portrayal of lilies, *Study in Blue*, by Tanya L. Wildgoose, concentrates on the structure and tonal qualities of the flowers using only shades of blue and white, rather than a realistically accurate color study.

ABOVE Shirley Williams was inspired by the brilliance and intensity of the colors and the aggressive shapes of both flowers and foliage to draw *Rhapsody in Blue*. This has been heightened by the strong blue background and the way in which the flowers have been allowed to "jump out" of the painting at the top and sides. Pastel on 00 Flour paper.

USING PASTELS

Pastels are applied in three basic ways. They can be used for linear drawings, and the advantage of pastels is that the intensity of the line will vary considerably with the amount of pressure applied. Second, they can be laid down in areas, and then blended together, which produces a paint-like quality in the picture. The third method is to build up a picture using individual strokes of different tones, laying these side by side, or across each other, without rubbing the area in. This method achieves its effect by the contrast of the separate colors, which constantly work against each other, while fooling the eye into seeing a third color, the combination of the two. Most pastel workers happily use all three methods, depending on the area in which they are working.

It is difficult to achieve a high degree of detail in a pastel drawing. It can be done, but requires immense patience. To achieve a point on a pastel is difficult, and the softer the pastel, the harder the task. With dark lines the answer can be to draw the lines with the dark pastel, and then to paint over these with the light pastel of the surrounding tone, on either side, to give the required width to the dark line. This can add a certain degree of finesse to the picture, but for the most part it is easier to attempt general impressions rather than concentrate on detail. Detail all too readily sinks, or blows away with a careless brush of the hand. However, detail should not be abandoned altogether. A focus is needed in any picture, and you can provide this with pastel, even though on a larger scale than with a pencil drawing. It is also as

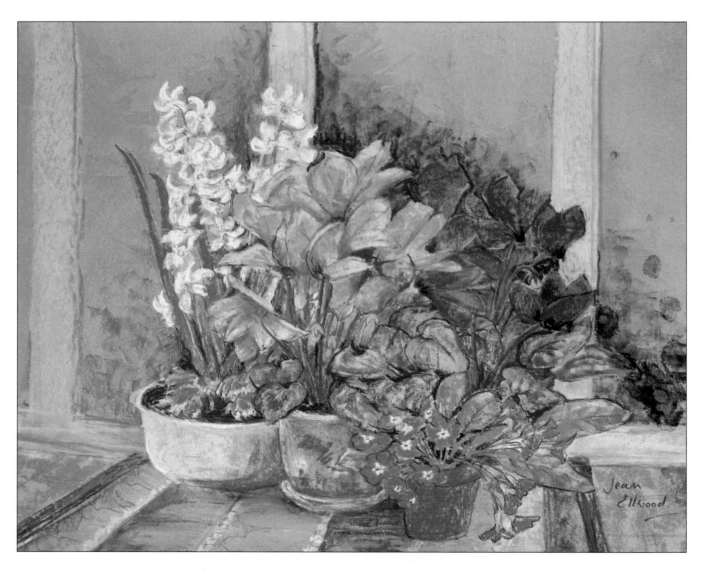

ABOVE In this study of pot plants by Jean Elwood the pastels are used to define the outline of the flowers. The background allows the natural color of the 00 Flour paper to show through to good effect.

well to remind ourselves at this point that general impression is not synonymous with sloppy observation. Just because you cannot portray the fine detail of pollen on a stamen, it does not mean that you should ignore the shape of the petals or bracts.

Now let us consider mistakes and changes. Few artists are so positive that they never make a mistake, or never decide to change a composition. In this respect soft pastel is wonderfully kind. In the early stages of a drawing it is usually possible to lift almost all traces of a line, using a kneadable putty eraser, or fresh bread (white sliced bread will work wonders). Pastel is an extremely messy medium for working, and even the cleanest worker will find that they have smudges and fingermarks around the edges of the drawing. When the drawing is simple, and you want the ground color of the paper to show, it is worth remembering to clean the picture with a putty eraser, before applying fixative. Once you have applied fixative, you can no longer lift anything with a putty eraser.

For later stages in the drawing, it is still possible to apply changes using the putty eraser or bread. Areas can become overworked, and the pastel may be too thick to give clear overlaying lines. Maybe you decide that the shape of the overall composition is wrong, and that you need a light flower where you have just drawn in a heavy background. For this apply the putty eraser. It will render you a rather dirty layer of paper, but the tooth of the paper will be restored, and you can then work over the area again. Again, however, if you have already fixed the area, this method of changing a drawing is impossible.

ABOVE A loose arrangement by Shirley Williams, titled *First of Spring*. Randomly bunched flowers create a soft, ethereal effect, with a gentle "S" curve in the composition. Pastel on 00 Flour paper.

LEFT In this drawing, *Jaws*, by Shirley Williams, an abstracted close-up view of a cactus allows a predatory impression to dominate the picture. Pastel on 00 Flour paper.

MARIGOLDS

H I L A R Y L E I G H

This drawing in soft pastels on Ingres paper aims to catch the Provençal brilliance of the flowers.

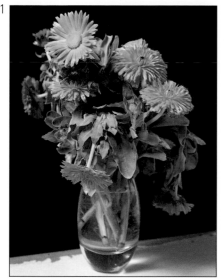

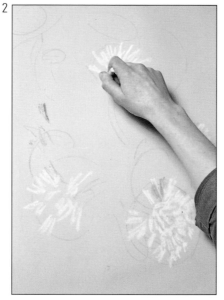

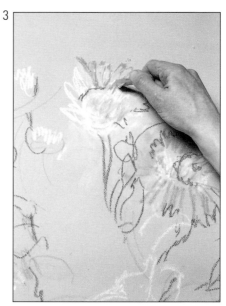

1 The vase of marigolds is the basic subject and will be rearranged on paper to produce an interesting composition.

2 The first flowers are positioned using pale cadmium yellow soft pastel.

3 The artist freely sketches in leaves, stems and some detail of the flowers.

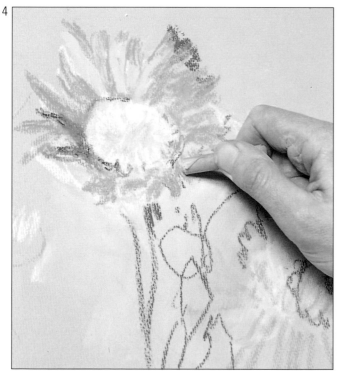

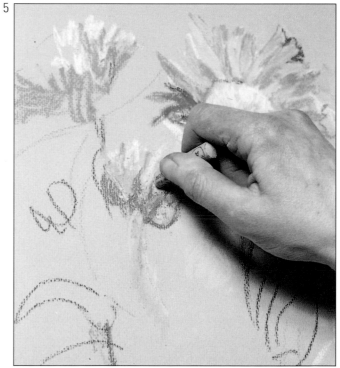

4 Various shades of yellow and orange are used to portray the color of the petals.

5 The first green is added, with lizard green giving the foundation color.

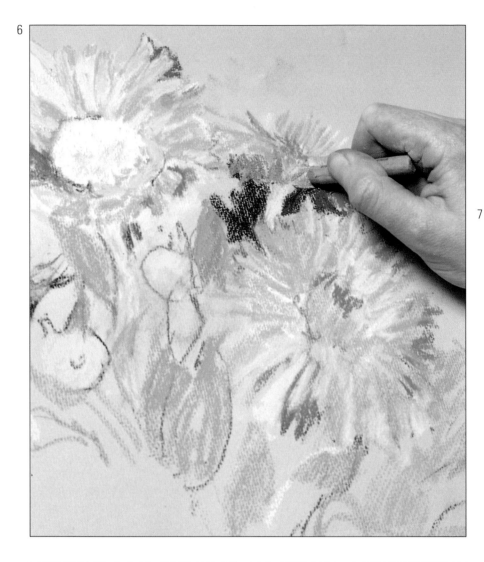

6

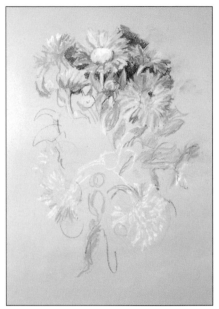

7

6 Prussian blue has been used to give the deepest tone between the flowers.

7 The overall composition has now taken shape.

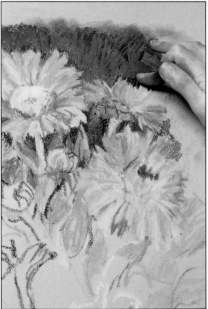

8

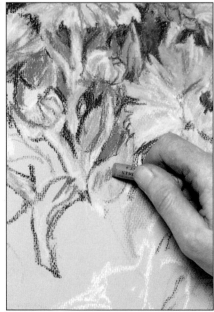

9

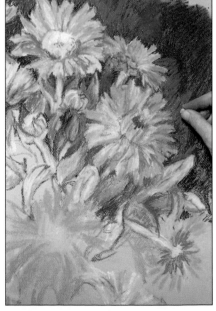

10

8 The artist uses her fingers to blend Prussian blue and mid-tone purple-blue at the top of the drawing.

9 More work is done on the foliage, using a mix of lizard, sap and olive green.

10 The background is extended, with the purple-blue tone throwing the golden flowers forward.

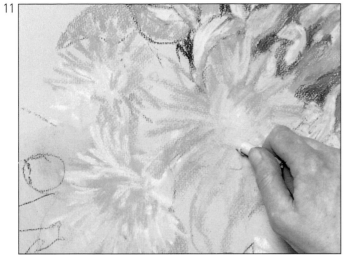

11 The artist turns her attention to the central cluster of blooms.

12 More background is added and again fingers merge the colors.

13 Detail at the center of the marigolds is achieved by using madder brown.

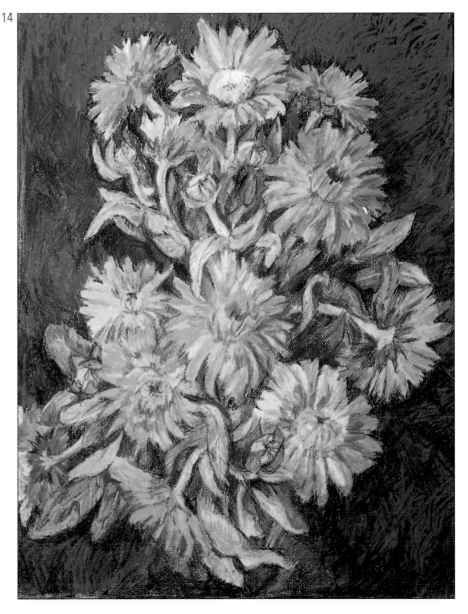

14 The finished picture exudes all the warmth and vitality of the Mediterranean.

FIXATIVES

The use of fixative is a very vexed issue. Many teachers advise against using fixatives since they alter the nature of a drawing. They cause the grains of chalk in the pastel to flocculate in little lumps, so the surface of the picture becomes less powdery, and less light. The color appears to sink. The nature of the surface is altered, too, when it comes to applying further layers of pastel. It becomes harder, and uneven, so that regular smooth strokes of pastel are very difficult to apply. For this reason most pastel artists feel very ambivalent about the use of fixatives. Degas used a fine mist of water, and this method is recommended, or else use a standard fixative only when the drawing is near to completion. Additional highlights can then be added, to compensate for the sinking that comes from the fixative, before adding the final fix.

There is a place for fixatives, because without their use, the drawing is extremely vulnerable. The slightest brush will damage the surface. Therefore, when you eventually consider how to present your work it is worth remembering that if you have used light fixing methods, when it comes to framing you are going to need a more substantial window mount, to prevent the pastel coming into contact with the glass.

Pastel remains a delightful medium for portraying flowers. There are many different types of pastel on the market and by experimentation you will find the type that best suits you.

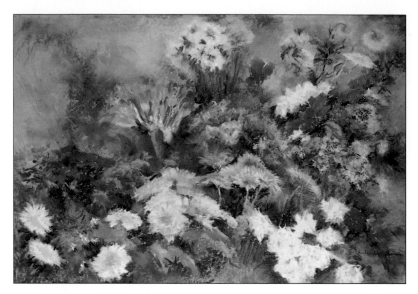

ABOVE Shirley Williams has made excellent use of dark and cooler tones between the groups of flowers to give depth to the picture. Added brightness is achieved by using some complementary colors in this portrayal of a summer bed. Pastel on 00 Flour paper.

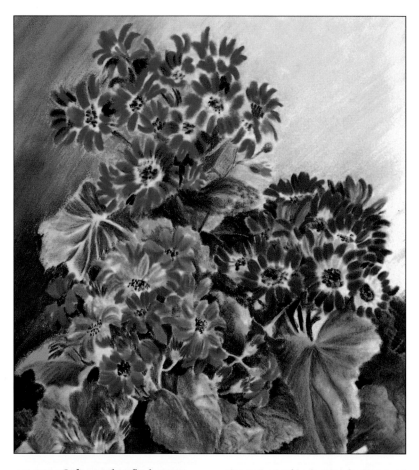

ABOVE Soft pastel on flock paper concentrates on the brilliance of these cinerarias in this drawing by Margaret Stevens.

MIXED MEDIA

Mixed media are frowned upon by some purists, under the false assumption that "them that can do, and them that can't go for mixed media". This simply is not true. It takes considerable skill to utilize a variety of media and to combine them all to produce a picture. It is the equivalent of adapting all the European languages to create a new "Eurolanguage".

Because of the difficulty of achieving success, it is all too easy to associate mixed media with the gimmicks that are frequently used as a substitute for skill. You can achieve quick results by scribbling oil pastel or wax crayon onto a sheet of heavy paper, covering this with thick black paint, then scraping through to the color beneath. However, the result is not necessarily a work of art but can often be surprisingly successful.

RIGHT A watercolor, gouache and pencil study of rhubarb and sorrel by Jean Elwood in which the pencil has been worked over the paint to add depth and detail.

BELOW For this evocative picture on T. H. Saunders watercolor paper Ann Thomas has used watercolor with salt thrown onto the wash before it dried. Then it was overworked with crayons, pastel and gouache to perfectly capture the fluffy dandelion clocks in a natural setting.

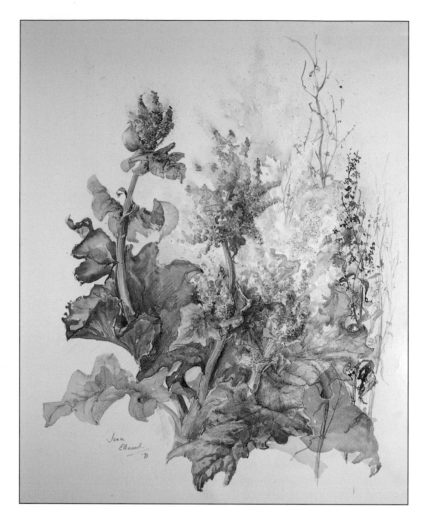

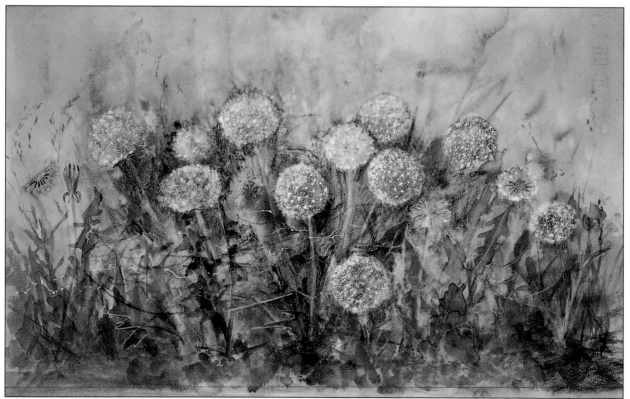

COMBINING MEDIA

Combining your media demands a great deal of care and tact, and the knowledge of how each of your chosen tools will react against its fellow. For instance, you must be aware that oil and water do not mix. Therefore, if you draw with white oil pastel on paper, the oil will act as a resist when you paint watercolor around it and the area will be left highlighted. The property of this type of highlight is utterly different from that which is made by using masking fluid. In this context it is possible to use resists varying from gouache to candle wax. Hence lots of experimentation is necessary, in order to sort out how to combine the various possibilities.

RIGHT **Candle wax, used as a resist, with gouache, has perfectly captured the color and texture of the bromeliad leaves in this picture by Jean Elwood.**

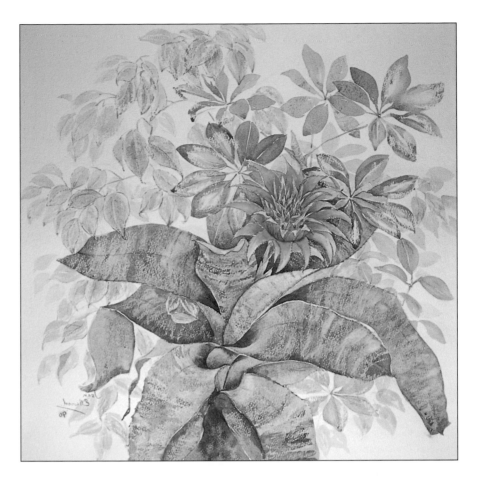

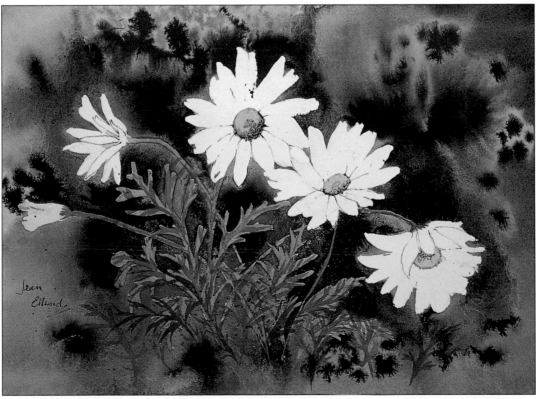

ABOVE **In this picture by Jean Elwood the daisies were drawn first and covered with masking fluid before a** watercolor wash was applied overall. Ink was dropped on while the wash was still wet and allowed to run freely. When dry, the masking fluid was removed and the flowers were tinted, the centers being picked out in ink.

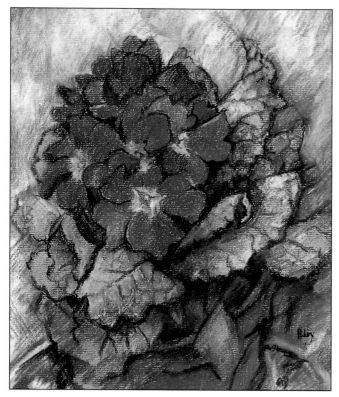

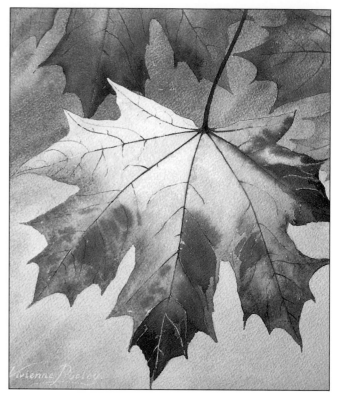

ABOVE Hilary Leigh has given added importance to the strength of color and shape of these primulas by using ink on top of the pastel. Worked on Ingres paper.

ABOVE RIGHT A study in watercolor and gouache with ink by Vivienne Pooley, which gives a very good impression of light shining through an autumn leaf.

BELOW Candle wax was used as a resist by Jean Elwood on the twisting stems of bryony, before working with a mixture of watercolor and ink.

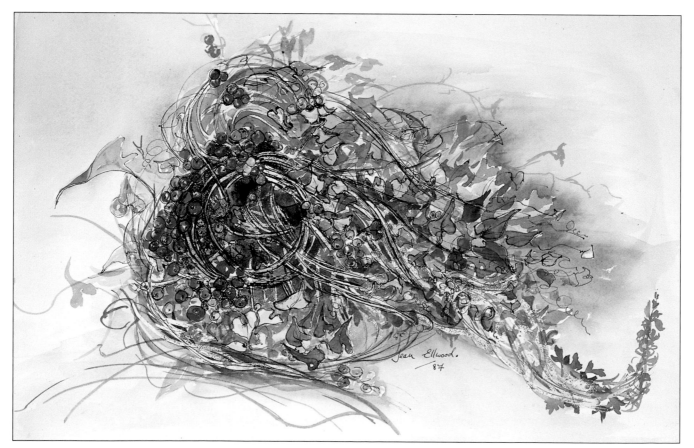

If you place pastel over an ink drawing it will tend to obliterate the penwork, because it is an opaque medium. It is possible to draw penwork onto pastel, but if you use tubular nibs or fiber tips the powder of the pastel will clog the nib. In this context old-fashioned mapping pens are the most suitable. You will find that true watercolors are infinitely more translucent than watercolor pencils. Graphite pencils produce a much stronger line, when drawn on top of watercolor, rather than on plain paper. (The water or the pigment gives added bite to the paper.) In other words, using mixed media requires plenty of experience, which you mostly have to acquire by trial and error, finding out what is going to suit you. Work your way through all the techniques associated with pencil, pen, paint, pastel and conté. Try out all the effects of masking, rubbing, spraying, and so forth. Slowly you will acquire a sixth sense of what is likely to work for you and suit your style.

ABOVE **A silhouette watercolor of spray chrysanthemums by Jean Elwood, sharpened in places by pencil outlines and hatching.**

As a general rule of thumb, it is true to say that as long as the interacting media do not overtake the purpose of the picture, then all is well. It is totally reasonable to combine whatever media will best convey the picture that you wish to present, and very often the viewer will not even realize that mixed media are involved, seeing only a happy combination that conveys a beautiful flower or arrangement. Try starting a drawing with pencil, then outline the important areas with ink, add a few washes and heighten the whole with a mixture of watercolor pencils and ordinary colored

pencils. This is mixed media. On a grander scale you might then add a few finishing touches of pastel, to give a more interesting texture to the whole. Charcoal or conté might add depth to a pen drawing, or pen be added to a watercolor. It is all a matter of what seems appropriate at the time. Practice and experience will govern which combinations of materials you apply to which flower. Given the fact that you are concentrating on presenting a picture of a flower, the media used are only going to be a vehicle – the medium will never become the message.

ANEMONES

H I L A R Y L E I G H

This drawing is made with watersoluble pencils on a good quality
watercolor paper.

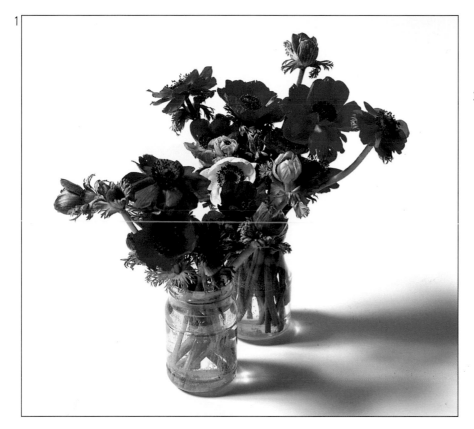

1 Two bunches of anemones provide the inspiration for this study which is not intended to be an exact reproduction.

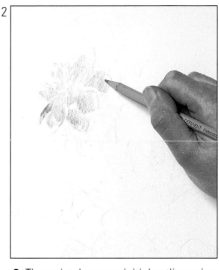

2 The artist draws an initial outline using a deep vermilion pencil.

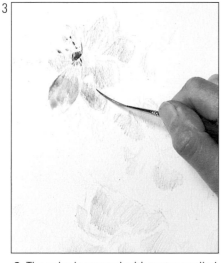

3 The color is merged with water applied with a fine brush.

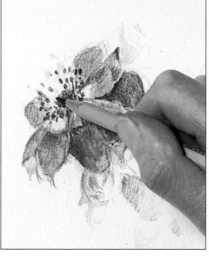

4 Detail at the center of the flower is achieved by using a mixture of dark violet, burnt umber and burnt carmine.

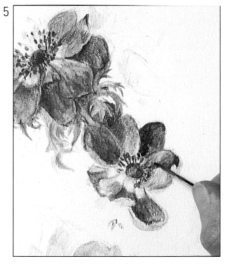

5 Intensity of color is built up by applying more dry pencil on top of the pre-washed sections. This dry, wet, dry, wet technique applies throughout.

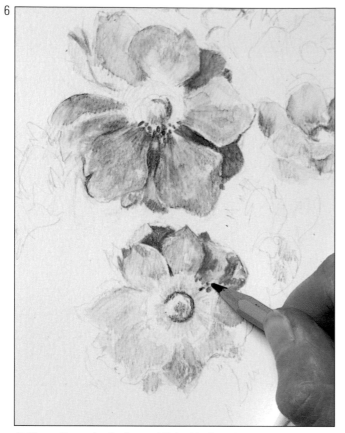

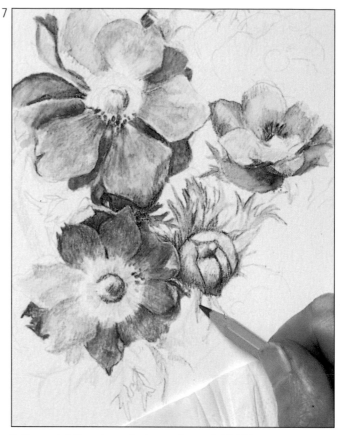

6 The pattern of color is established by introducing mauve flowers between the reds.

7 Fine-cut foliage is worked on, using an initial May green followed by sap, olive, juniper and cedar.

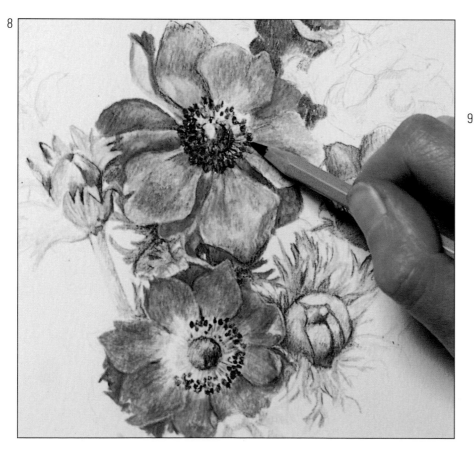

8 Detail is brought out on the central mauve flower using blue violet, light violet and Imperial purple.

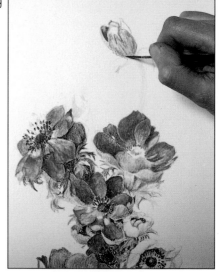

9 The artist adds a bud at the top of the drawing, extending the stem to improve the composition.

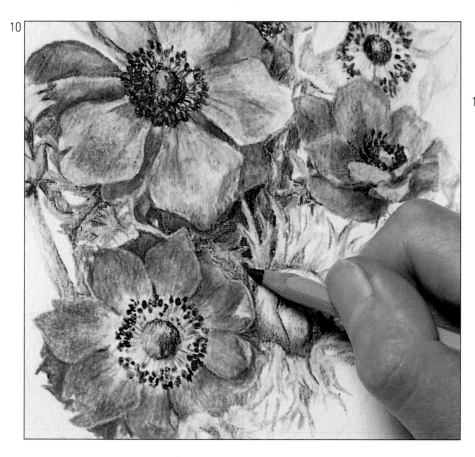

10 Depth is achieved by using an indigo pencil, dipped in water, which gives the darkest tone to the center of the study.

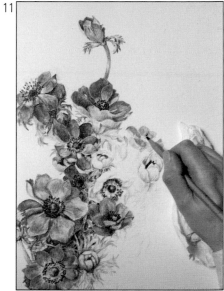

11 The half-moon composition is filled out by adding a semi-profiled flower at top right.

12 The composition is extended further with an opening bud at the bottom right to lead the eye downwards.

13 Darker tones are added to give stability at the base of the picture.

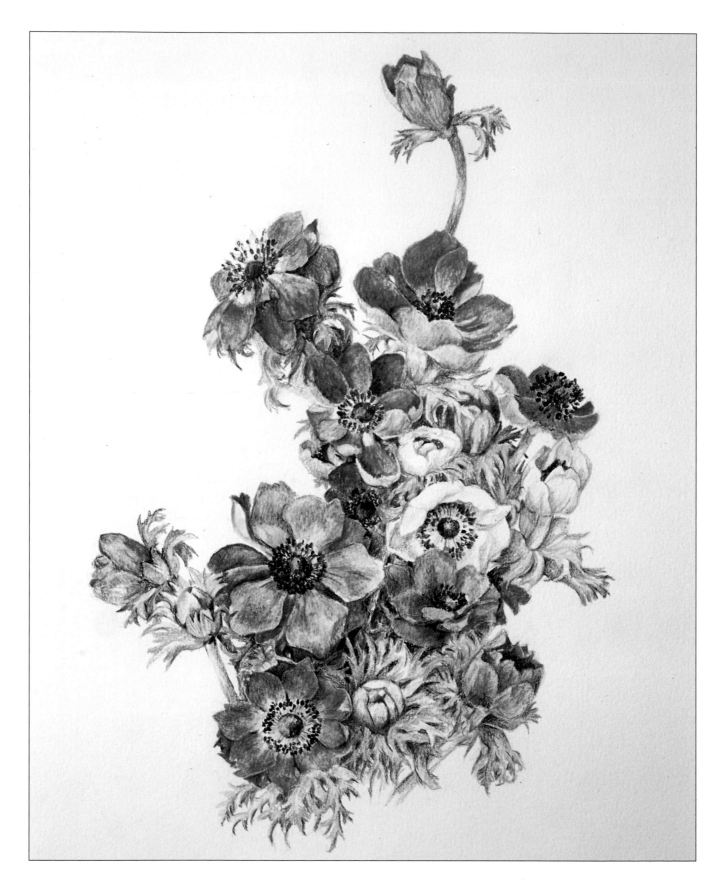

14 Final touches of color have been added to capture the glowing colors of the flowers.

WATERCOLOR PENCILS

Watercolor pencils are a relatively new medium. They have only been on the market for the last couple of decades, so hard and fast traditions for application do not exist. Their advantage over traditional colored pencils is that by applying water you can fill in the grain of the paper, and by softening the pencil with water, you can apply far more pigment. Therefore it is possible to achieve great depth of color. The disadvantage of this medium is the disadvantage of all stick media. You are at the mercy of the manufacturer for the choice of colors. For years we have been limited to sets of 48 colors, but now some manufacturers are bringing out sets of 72 pencils and the more colors you have to play with, the more subtle tones you can achieve.

All the basic rules apply. Firstly, choose the paper. As water is to be applied, you need a reasonably heavy paper, certainly 90lb (185gsm) or 140lb (300gsm) watercolor paper. The choice of tooth or Hot Pressed is tricky. A sort of halfway paper seems to work best, so that the pencils will not just skim the surface. On the other hand you must ensure that the grain of the paper does not dominate, and Cold Pressed or fine NOT paper tends to work very well. Cotman acid-free paper is also good for such work.

There are two other points to be borne in mind when you start using watercolor pencils. The first is the time factor. Watercolor pencils, like colored pencils, are a very slow medium to apply. You can go for a hurried impressionistic effect, but application is by narrow strokes and takes a long time. Do allow for this. To gain depth and variety of color you will find yourself going over the same area several times with different tones of pencil, and the area may be very small. After a couple of hours you may find that you have worked on only one or two flower heads. Do not get depressed; your patience will be rewarded.

The second point is that these pencils are soft. Unless you are merely covering a large area prior to softening it with water, blunt pencils

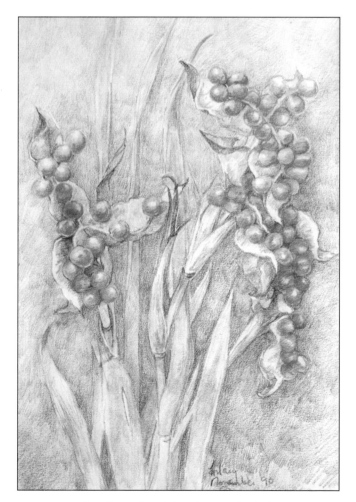

ABOVE **A colored pencil study by Hilary Leigh which conveys the glow of wild iris berries seen on a dull autumn day.**

ABOVE **Drawn with watercolor pencils, the red primroses by Hilary Leigh were blended with brush and water while the background and some of the leaves were laid "dry", with the tooth of the paper still showing. This has the effect of bringing the flowers forward.**

will not do! Keep a good sharpener handy, and lots of tissues. Continual sharpenings create a lot of wood and pigment dust. The tissues are for dusting your picture and for blotting excess water from your brush. When you begin work, set up your composition in the usual manner, and, as usual, take a good hard look at it. If you are right-handed it is easiest to have your water pot on the right-hand side, making it less likely that you will drip water on the drawing. You will probably finish up holding a lot of pencils in your left hand and with pencils on both sides of the board. It is also useful to have an ordinary graphite pencil and a good eraser to hand, along with a couple of brushes, possibly a size 3 and size 1. To begin with, it is easiest to rough out the composition with an ordinary pencil, so that you have an idea of how the whole picture will fit together. Then start to apply the watercolor pencil. Start on a small area, and work that up, before moving on to the next flower. Flowers can move a great deal in the time it takes to finish one bloom, so this method of working can save a lot of frustration.

There are three main methods of application. Firstly, dry pencils can be applied in the normal manner, using parallel shading. This will give an even color distribution, and the side of the lead is used to give as broad a stroke as possible. Hard edges are applied by using the pencil more vertically, when it is important that the pencil point is sharp. These colors can be mixed and overlaid to give greater variety of tone. Juxtaposition of different tones of the same color will give liveliness to a petal. In nature one rarely sees flat matt colors, and in a

ABOVE Working from photographs is not ideal but can be the only solution in mid-winter when fresh flowers are unavailable. Make sure they are your own photographs and not an infringement of someone else's copyright. This study of "Caroline of Monaco" roses by Margaret Stevens is made from photos taken the previous July in a vain attempt to capture the brilliance of summer. The roses are drawn and covered with masking fluid, then a green wash of watercolor applied over all. The background is worked up with watersoluble and polychromos pencils before removing the masking fluid and the details of the roses added with both wet and dry pencils.

drawing the overlaying and mixture of, say, carmine red, geranium scarlet, and crimson lake, may help to imitate this abundance. Therefore, even in the early stages, it is normal to find oneself working with three or four tones at any one time. Tones can be lightened slightly by the use of a good eraser, and faint lines all but eradicated.

The second method is to brush an area of color with water. This will blend and dissolve the individual particles of color, giving a traditional watercolor appearance. The particles will then settle evenly over the whole surface of the paper, giving a far more solid color. You will no longer have those little specks of white showing through,

where the dry pigment has not completely obliterated the tooth of the paper. For laying down initial color this is a wonderful practice, although it is worth remembering to do this before you go into too much detail of color tone. For later stages of working it should always be remembered that when you use a brush, you are lifting the color to dissolve it in water. Therefore dab the water on with extreme care. Even so, with areas of heavy pigment, it is very difficult to achieve an even wash. The converse of this argument is also true. However difficult it may be to keep a heavy wash down on the paper it is also easy to lift color off. Adding water, and then gently lifting the pigment with the edge of

a tissue will frequently achieve the desired tone.

The last method is to wet the tip of the pencil itself. This will provide areas of intense color, and is thus very useful for highlights. The dark pencils are particularly good in this respect, because even vivid purples can produce an intensity verging on black but giving far more life to the image. The main problem to watch out for here is that the point of the pencil is softened by water. The point will therefore disintegrate even faster than usual. A second vital fact is that until the pencil has dried out the intense color will jump onto wherever you apply the pencil. It is all too easy to forget that you have just dipped the pencil in water. To avoid accidents remember which pencils have been in water and allow the tips time to dry out.

As always with stick media, it is difficult to find a naturalistic green. Green is a problem for landscape artists and perhaps an even greater one for flower painters. It is never more so than when you have to mix it from the unlikely colors that are commercially available. The yellows and blues provided never seem to produce a satisfactory substitute, so you will probably try to tone down the viridian hues with olive green. This never seems to work either, and a likely solution to the problem is to begin by using the most improbable yellow-green as a base for most leaves. If you then add to it with the gray-greens, the darkest green, dark blue, olive green and even the dark browns and purple you can usually achieve something that is a rough approximation of a natural effect. Very often the yellow-green seems too insistent, and this is one of the times when you should lift excess color with a wet brush and tissue.

ABOVE **Gouache and watercolor combined with an outline in felt-tip pen cleverly link the flowers to the design** on the fabric to create a lively and vibrant picture of tulips and geums by Jean Elwood.

When the area is dry it is then possible to rework, applying delicate overlays to gain the desired effect.

This is a relatively slow medium. Extreme detail is hard to achieve because of the soft pencil point, so it is not a method beloved of most botanical painters. However, watercolor pencils can produce a soft, delicate drawing, with an enviable intensity of color. For those of us who prefer a harder point to the softness of a brush, with patience these pencils will work for us, producing a delightful cross between painting and colored pencil work.

ABOVE **This pencil and pastel drawing of a valuable plant, Cycas revoluta (the dinosaur plant), was made from the top of a ladder at Bangor University Botanical Gardens. This was the only way for Maggie Parker to see the rather "furry" fruit, which cluster in the center of the fern-like fronds and which provided food for dinosaurs, hence the plant's nickname.**

PENCIL

Working with ordinary "lead" pencil, or graphite, is not necessarily a speedy process, and the artist should take as much care as if it were a delicate watercolor. All the same nuances of tone and texture are possible and only the color is missing. The resulting artwork is just as highly appreciated by the collector and will often fetch good prices at exhibition, even being judged best in show by the visiting public.

If the drawing is for posterity and not a short-term project, it should be executed on the best quality paper you can afford.

Pencils are held in different ways in order to achieve different results. A fine pencil held upright in the writing position will give a clear, clean line. Held towards the horizontal between forefinger and thumb thus bringing the side of the pencil, or crayon, into contact with the paper gives a broad stroke which will shade and soften the image.

Varying degrees of hardness (H) will produce a paler line or shade. Running down the scale of Bs towards 6B will give darker, softer lines or shade. This is, generally speaking, not appropriate for flower work and the darkest areas can be equally well built up by overshading with a 2B or 3B.

This basic technique applies just as well when using conté drawing pencils or any non-soluble colored pencil. Whatever you use make sure that you keep a good point as a worn-down stub will give poor results. The pencil sharpener and ideally a piece of fine glass paper should be on hand whenever possible.

Remember that a "toothed" paper is best for crayons and colored pencil so that the pigment can bite on its surface. Having said that, a flower study in colored pencil is not likely to be very large, so a very grainy paper can look out of place.

BELOW LEFT An interpretation of a "Star Gazer" lily in pencil by Robert E. Miller. The leaves are well shaded and there is a good feeling of depth conveyed at the heart of the flowers. There is, perhaps, an unfortunate juxtaposition of bud and flower at the top of the stem, making it hard to detect where one begins and the other ends. Note that the pollen-bearing anthers have been removed from the stamens by the florist, to prevent staining of clothing when handling. A sad process of emasculation!

BELOW RIGHT This study of spray chrysanthemums was executed by Doreen Miller. The lively line of the spray and the varied twists and curls of the petals have been very well observed, likewise the suggestion of complexity in the centers of the flowers.

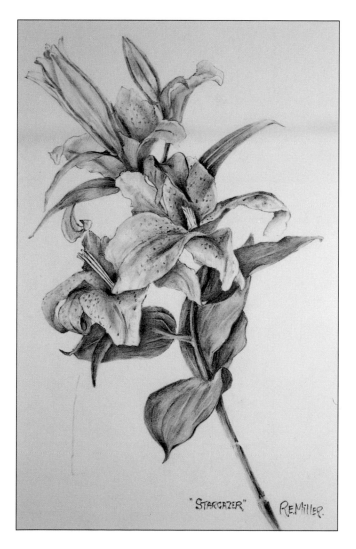

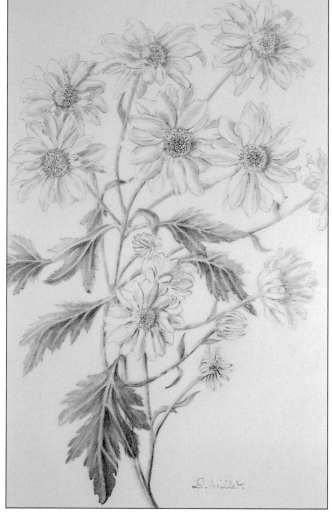

NOT is about right. Sometimes a plastic eraser may be used to lift or soften patches of delicate shading. Some artists like to use a finger to gently blur and merge shaded areas while others chose to use a stump, or even a cotton bud. The soft luxury brand of kitchen towel wound over a stub of pencil and held in place with sticky tape will serve the same purpose.

Whether or not you spray the finished artwork with fixative is a matter of choice and depends on its ultimate use. If it is likely to be handled, say in a design context, or kept as part of a portfolio, then fixing is appropriate. If, on the other hand, it is to be glazed and framed then fixing is best avoided.

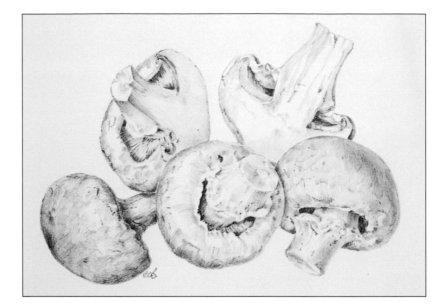

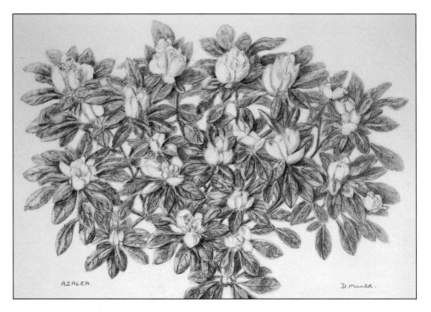

RIGHT ABOVE **A pencil drawing of mushrooms by Brenda Benjamin using HB, B and 2B on 140lb (300gsm) Arches Hot Pressed paper. The suede-like texture of the skin has been well portrayed, giving the feeling that only a knife is needed in order to peel them!**

RIGHT MIDDLE **This picture of a potted azalea by Doreen Miller proves that the artist is not frightened by a complicated subject. The complexity of the leaves is quite daunting, and although the botanical artist would tackle the subject differently – showing one flower sprig in detail with just a line drawing of the whole plant – this is a very good exercise in leaf arrangement and shading.**

RIGHT **An example of fine pencil work by Julie Small in which the contrasting textures of leathery holly leaves and delicate bracken fronds is ably captured.**

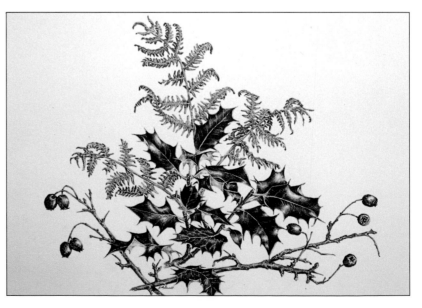

IRISES AND HYACINTH

M A R G A R E T S T E V E N S

The rich blues of these flowers are ideal for a drawing using colored pencils on a support of NOT watercolor paper.

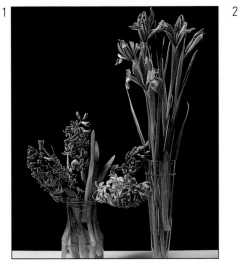

1 Time does not allow all these beautiful flowers to be portrayed.

2 The artist first makes an outline drawing of the iris using light ultramarine. Zinc yellow shading is added and deep cobalt is used to shade the petals.

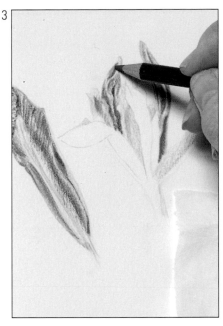

3 A mix of deep cobalt and Prussian blue is used to contour the petals, with purple adding the deepest tone.

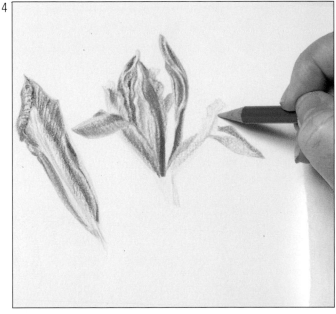

4 A little carmine supplies the pinkish tinge where it is needed.

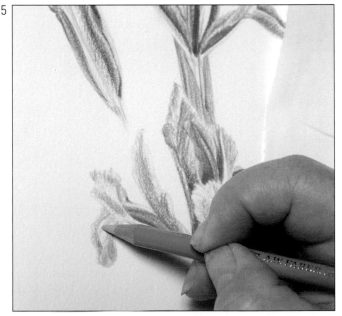

5 Ocher over zinc yellow shades the falls. You will see that no attempt has yet been made to position stems or leaves.

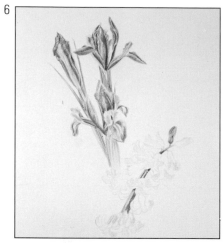

6 The hyacinth is drawn in to cut across the front of the irises. The stem uses an interesting mix of Hooker's green, red violet and deep cobalt.

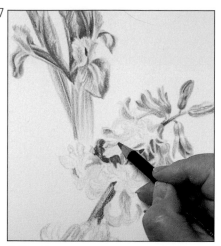

7 The flowers are worked up using similar tones to the iris, but with less deep blue and more carmine and purple.

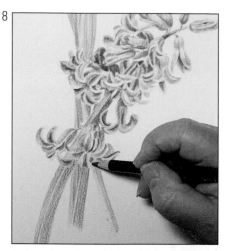

8 The stems have been added using a mixture of zinc yellow, moss green and Hooker's green. Now dark touches of detail are added to the hyacinth bells.

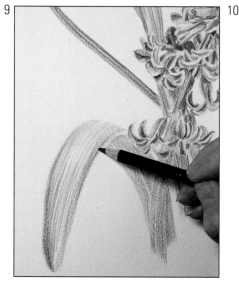

9 The imposing curve of the hyacinth leaf is contoured with slight touches of dark gray.

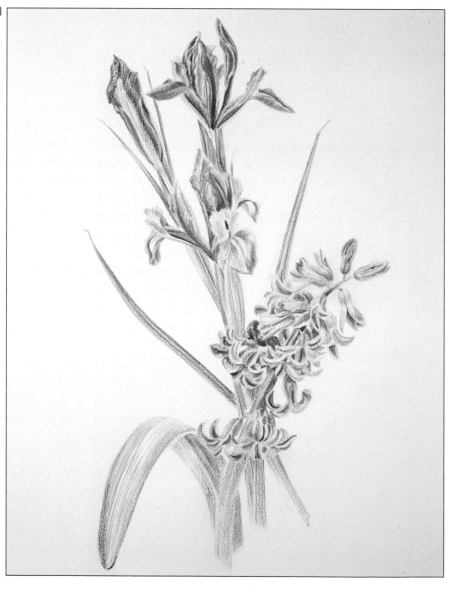

10 The result is a clean, simple study, with the angular iris balanced by the curvaceous hyacinth.

FREESTYLE PENCIL

Freestyle is an announcement of the fact that in this section anything goes. Botanical drawing is governed by careful controls, to demonstrate how leaves and flowers are formed and grow, so all outlines and shading are designed to work towards that end. With freestyle, however, the artist owes no positive allegiance to this creed. You are out to recreate a flower, in a drawing, by whatever means suit best. This does not mean that you will not impose method on yourself. A drawing that admits no control is unlikely to become a "thing of beauty and a joy forever".

To begin with, it is necessary to consider which particular aspect of the flower you wish to bring out. You may wish to emphasize the solidity, or the whiteness, or the flame-like quality of the petals. Each aspect requires a different approach. White may be described by emphasizing the darkness of the space surrounding the flower. Solidity could require careful modeling of the petals, with build-up of cross-hatching or other shading. The moving quality of the whole flower might best be conveyed by the continuation of the curves and lines to their logical conclusion.

Once you have considered all these aspects the type of pencil you

ABOVE RIGHT A freestyle pencil and watercolor study of a *Houseplant Arrangement with Cyclamen* by Jean Elwood where large areas of pencil have been left to provide an excellent counter-balance for each other. Worked on Fabriano No. 5 paper.

RIGHT A freestyle study in pencil of magnolia by Hilary Leigh using straight-line and hatched-shading techniques with the background successfully throwing forward the white blooms of the magnolia.

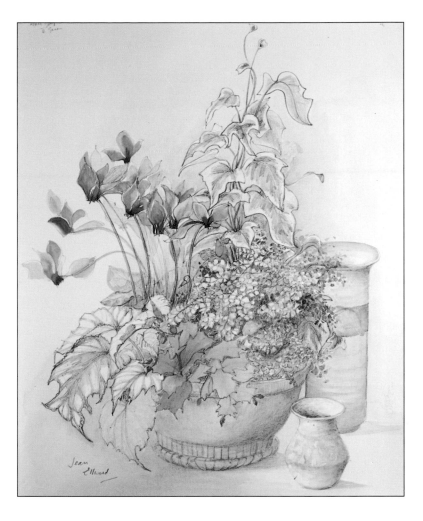

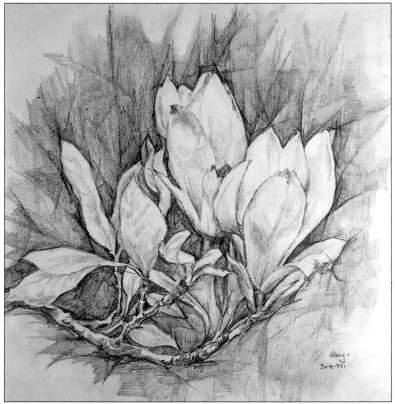

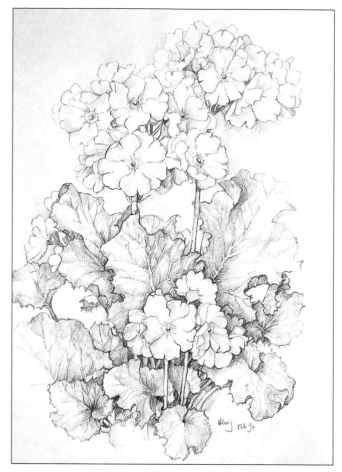

need to use will be obvious. If you are describing the space around a flower it is likely that you will require a soft pencil, 2B or 4B, to give impact to that area. Modeling an area is likely to need a far harder pencil, with greater precision. When it comes to extensions of lines, the choice is yours, but you are likely to start with a medium pencil, and then build up as required. A fine propelling pencil is useful because the lead does not need sharpening and gives a fine line. There is also an attractive, variable quality to the graphite – sometimes it will give a black line and sometimes a fine gray line. This gives variety to the drawing, because you can work on different areas, depending on how the pencil behaves. All the methods of shading that pertain to pens are also useful when drawing with

pencil. In addition you can utilize cross-hatching and use areas of graded shading. The depth of shade will be governed by both the pressure of the hand and the softness of the pencil. A 6B pencil will give an intensely dark shade, while 6H will be pale gray.

When it comes to edges you are no longer totally controlled by exact outlines. Freestyle outlines tend to be considerably looser than those governed by botanical work. You can describe the flower in a series of small straight lines, or by sets of curves. Loose, squiggly lines may be used for uneven surfaces, and spirals may be used for volume. Utilize the form that is comfortable, in order to create a positive drawing.

Drawings can be made on any ground that will give additional interest, so long as this is not a

ABOVE LEFT A freestyle watercolor and pencil study of passion flower fruit by Jean Elwood on Ingres paper.

ABOVE RIGHT The parchment paper, used as the support for this pencil drawing of a primula by Hilary Leigh adds interest to the picture, which has straight-line shading.

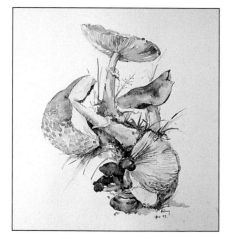

ABOVE A freestyle watercolor drawing of fungi by Hilary Leigh with straight-line pencil shading.

substitute for considered work. Parchment paper, for instance, is a lovely ground on which to work, as it takes pencil well, and also reacts well to an eraser. If you are drawing with conté then a colored ground of Ingres paper gives control to the dark tones, but sets off the highlights of white.

When working on a freestyle drawing there is one aspect which it is well to remember. The eye likes a focal point. It does not matter if this is a light highlight or a dark one. Our brains enjoy having a starting point in a picture. Therefore you will give added impact to a drawing if you provide anchorage points. This can be anything from a dark point on a line, to a dark or light area in the picture. If you are working with line, you need to create focal areas where the lines are focused with greater depth and emphasis, and in the overall pattern of the picture, it is as well to have one area that is worked with more contrast than the rest. This will give the viewer a place from which to explore the whole work.

Freestyle pencil work can describe almost any type of drawing that is not botanical. Anything really does go, but the only way you will find out about it is to try lots of different ways of expressing both yourself and the flowers. Practice will make perfect and improve not only your ability to comprehend flowers, but also your capacity to interpret them and portray them for other people.

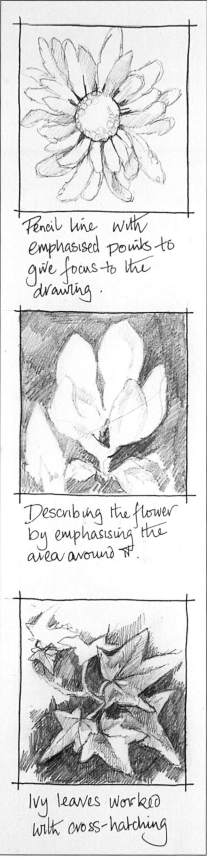

Pencil line with emphasised points to give focus to the drawing.

Describing the flower by emphasising the area around it.

Ivy leaves worked with cross-hatching

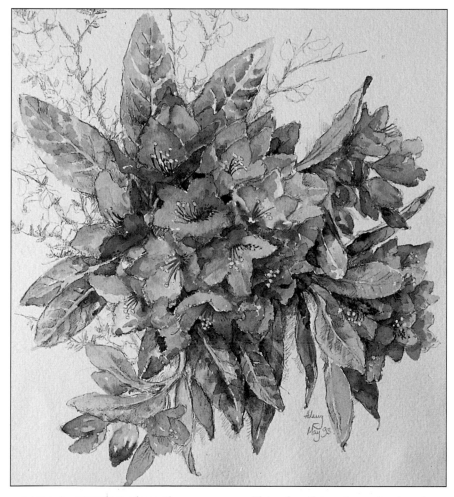

A B O V E A watercolor and pencil study of rhododendrons by Hilary Leigh, with touches of gouache, on hand-made paper.

A B O V E Different freestyle pencil techniques demonstrated in three simple sketches.

CHRYSANTHEMUMS

H I L A R Y L E I G H

This freestyle pencil and watercolor drawing on hand-made NOT paper illustrates what can be accomplished, relatively quickly, with this medium.

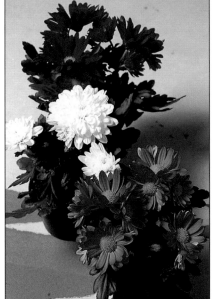

1 Three small pots of chrysanthemums are positioned on different levels, to give a pleasing curve of color.

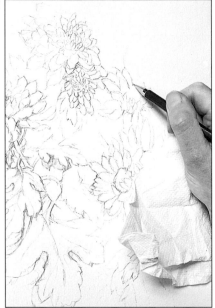

2 The artist makes short freestyle strokes, using a propelling pencil. The composition is built up using the live material as a guide rather than as the basis for an exact copy.

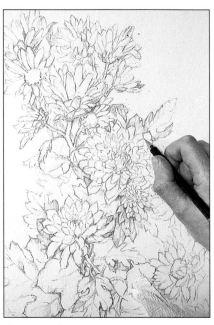

3 Areas of free cross-hatched shading are added to give form and depth overall.

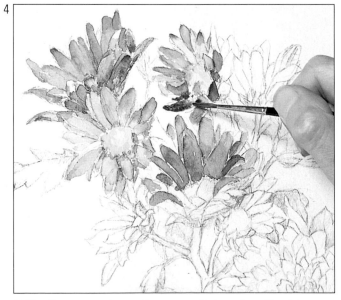

4 The first watercolor washes are applied, again without too much attention to color-matching the flowers.

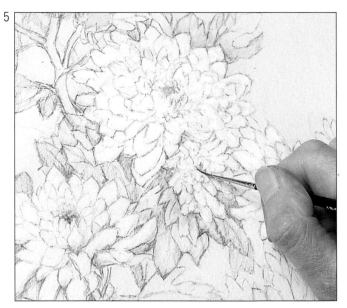

5 Chinese white is used with a slight staining of yellow at the centers.

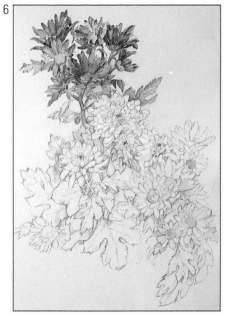

6 You can now see the overall composition building up.

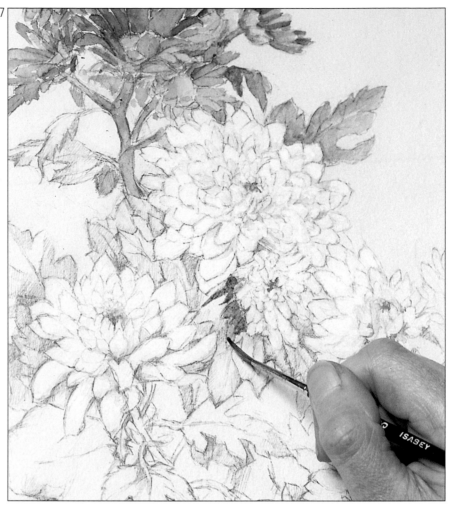

7 Dark green leaves help to project the white flowers.

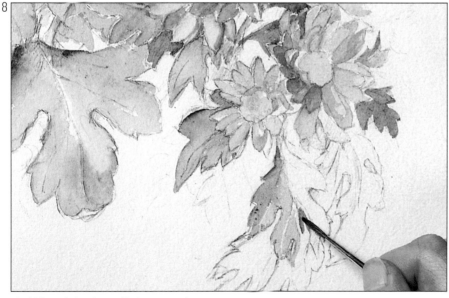

8 Although freely applied, watercolor washes are built up in the usual dark on light manner.

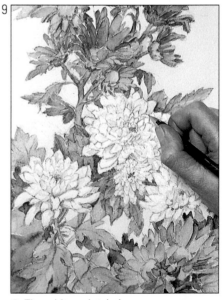

9 The white paint, being opaque, means that initial detail has been lost and this is now restored by over-shading in pencil.

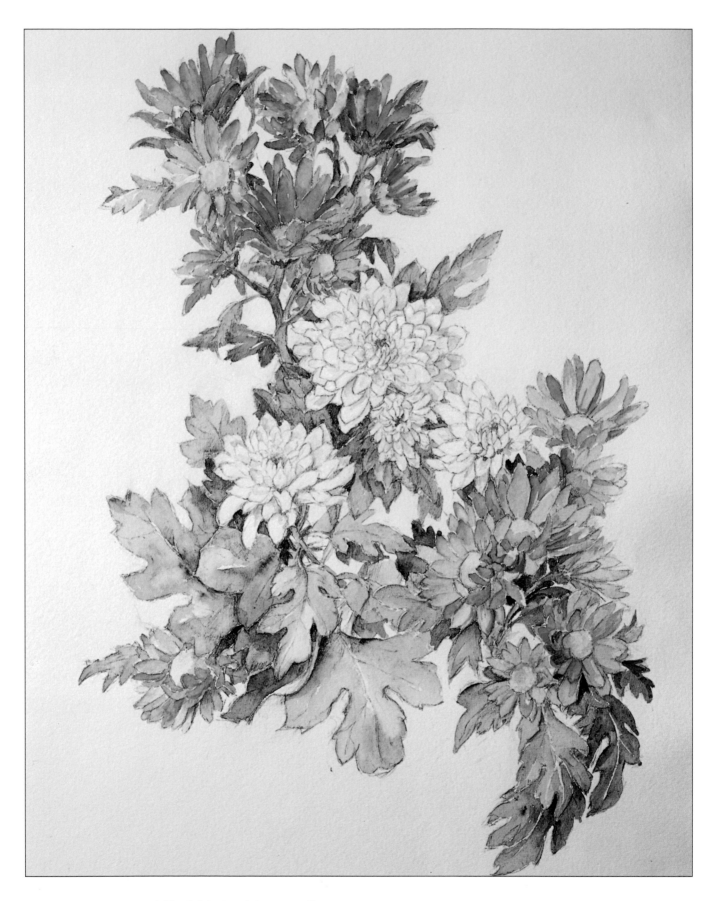

10 The finished study is a rewarding example of a day's work when overall effect, rather than photographic accuracy, is the aim.

PENCIL AND BRUSH

The combination of pencil and brush is probably the one most frequently used by the flower portraitist. At the simplest level the pencil substitutes for the pen in a line and wash study, while at the peak of achievement, as in the hand of a master like Redouté, the brush produces the finest of lines, turning each silken curve of a petal into a separate work of art.

Before starting a flower portrait it is best to sit and study your flower. Ten minutes spent in serious observation can prevent unnecessary errors and enable you to begin with confidence. If you feel it will help, do a rough sketch to familiarize yourself with the angle of the flower on the stem, or the position of the leaves. Note your light source and the highlights and shadows. Once again, a quick black and white study may help you.

Assuming you have selected the appropriate paper, either cut from a sheet or on a block, check that it is the right size. To try and cram a very tall lily onto a 10in (25cm) sheet of paper is ridiculous but not unknown. Of course you can reduce the size of the subject but if you try to over-reduce a majestic flower the result will prove unsatisfactory.

When all these factors have been considered, start the outline, using an F, H or possibly 0.3mm propelling pencil. Remember to keep a piece of paper beneath your hand.

Uncertainty shows if the line is broken, as if you are doing a quick sketch. Try not to stab at the paper with the pencil but keep the point down to make a smooth and even line rather than a feathered one. This is best achieved by keeping the heel of the hand on the paper to act as a pivot. As a general rule it is not wise to draw more than you can comfortably paint in one session. A leaf will twist or a petal unfold to the light, so, say there are two buds and three open flowers on a stem of lilies, draw in the two buds and the uppermost flower first, but only indicate the stem and position of the other two flowers. Work on those buds before they open and the first flower before it fully matures to match its sisters further down the

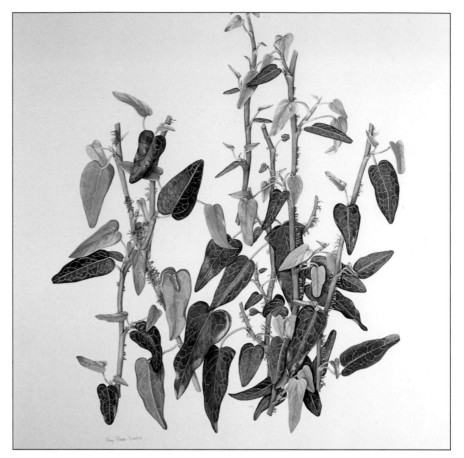

ABOVE Delicate brush drawing with water has removed the basic green pigment in order to depict the veins of *Hedera pastuchovii*. In a study of this type as much time can be spent removing the paint as applying it. Kay Rees-Davis has also used the brush to outline the aerial roots.

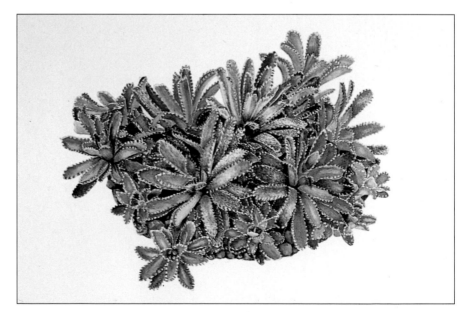

ABOVE This study of the encrusted saxifrage "Dr Clay" by Joy Luckas demonstrates the skill required by the artist in portraying a small plant. Not only are the leaves tiny but each one is intricately marked. An initial pencil drawing is followed by pale watercolor washes over each leaf, taking care to allow for the finely marked edges. No white paint is used and the silvery sheen is achieved by "washing away" small areas of paint in some places.

stem. That way you will keep abreast of change and not feel frustrated by it. With a smaller subject, of course, you can get the whole outline down on paper without any problem.

After the outline a watercolor drawing follows a well-tested and tried formula. Look for the palest shade and apply that wash first. Deeper hues are blended in, using a small-scale wet-on-wet technique. For landscape painters turning for the first time to flowers this is not an excuse to mix a huge amount of paint as if applying a broad wash to a huge sky. Flowers never require a large amount of paint in that way, so try to think small.

Once the flower is stained the brush starts its work as a drawing instrument. With the finest possible point and the minimum of water, pick up small amounts of the required pigment and lay it on in delicate hatched lines, to provide the shading, to model the curve of a petal and where necessary, to intensify the color. Again you require only a tiny amount of paint for this and no large quantity of wash on the palette is necessary. Try to think small and *dry*. This is when the layout of the materials on the worktop becomes important.

Dip the brush, perhaps a well-pointed size 2, into the water, then immediately touch it onto the pad of kitchen towel beneath the water pot, which will remove the surplus. Now lift the pigment onto the brush from pan or palette. If it seems "sloppy" go back to the kitchen towel and absorb a little more. Like everything else, practice makes perfect and after a while you will feel when the brush is correctly loaded.

BELOW **In this drawing of spray chrysanthemums and holly by Margaret Stevens the viewer's attention is drawn to the center of the chrysanthemums. Time spent drawing these areas in great detail with a pencil would be time wasted and it is far better to allow the brush to do all the work.**

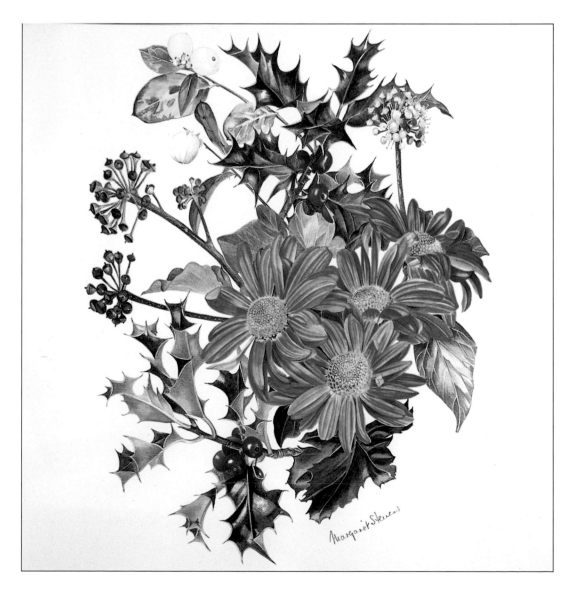

There are other times when the brush is very much a drawing tool, reverting to its historical role, one might say. One example is when a flower has a picotee edging. Only the carefully controlled point of the brush can lay on the color in a sufficiently fine line. When stamens are so threadlike and delicate that a pre-drawn pencil line would be too much, then mix a pale tint of "botanical gray" – French ultramarine and light red – which will indicate the shadow cast by the stamens while allowing the white paper to give them form.

White flowers are very dependent on the brush and white on white can

A B O V E This detail by Margaret Stevens shows the result of using the brush to create the outline in a picotee flower such as a carnation.

B E L O W This drawing of *Magnolia stellata* by Margaret Stevens demonstrates the use of the brush to model white on white flower petals, delicate veins, the "hairy" texture of the calyx and the lichen-enhanced bark. A good example of dry-brush technique.

seem a daunting prospect, but it need not be. Should the white flower be intended for publication, for a greetings card perhaps, it is necessary to show the petal edge a little more clearly than might normally be needed. It is best shown with a fine line of "botanical gray" rather than with pencil. Remember that as soon as watercolor goes over a pencil line the line cannot be erased and for a pale colored flower the pencil line should never be too dark or heavy.

When working on leaves the same method is applied – a pencil outline followed by washes of the base color. If it is a leaf with a high gloss

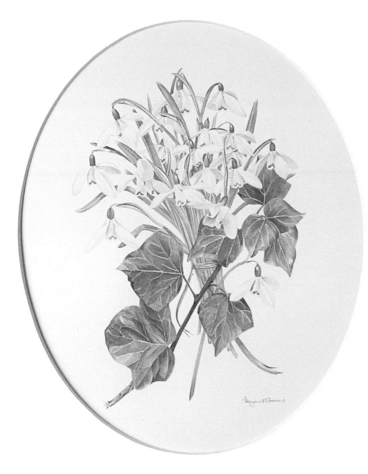

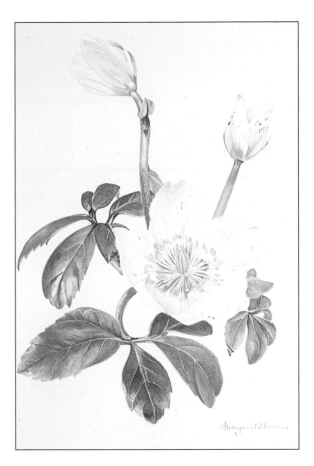

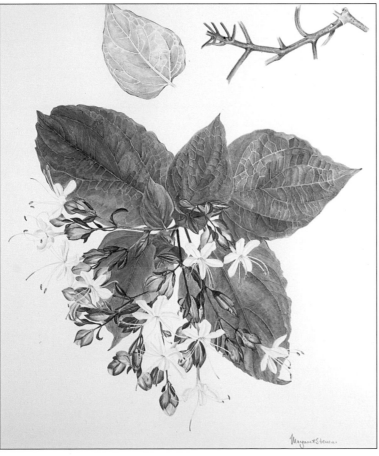

ABOVE LEFT Good use is made of "botanical gray" (French ultramarine and light red), in this study of snowdrops by Margaret Stevens, a typical "white on white" subject.

ABOVE RIGHT This portrait of a Christmas rose by Margaret Stevens depends largely on a brush drawing to create the image of the flower while dry-brush work sculpts the leaves.

LEFT This plant, *Clerodendrum trichotomum*, with its almost reptilian network of veins, depends on the brush to draw out the lighter areas and to hatch in the shading, thus creating texture. Drawing by Margaret Stevens.

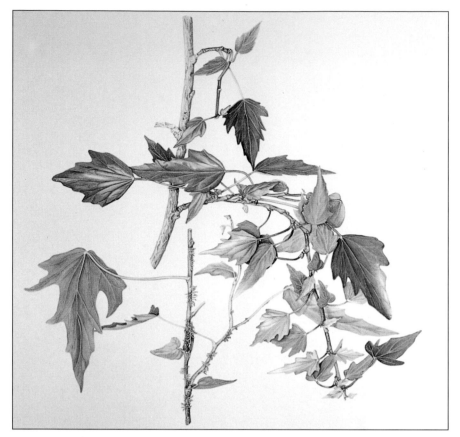

Another example of brush drawing on veins and aerial roots of *Hedera nepalensis.* **Kay Rees-Davis has** **also used the brush to depict the delicate detail on the bark in this fine study of a species ivy.**

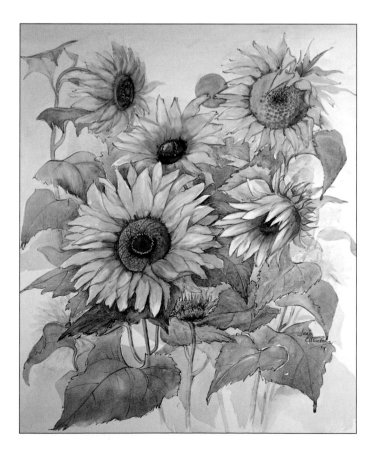

this first wash may be a very pale botanical gray. Then when the green hue is applied care must be taken to avoid the highlighted area. Only rarely is the highlight brilliant enough to need the white paper left exposed. In a pure watercolor drawing white paint is never used.

Again the brush becomes a drawing instrument when working on the veins, particularly with certain species. Primrose leaves are a classic example, as are some species of ivy, viburnum and so on. The brush is often used without paint, only water, and you will probably come to realize that you can spend as much time taking paint off as putting it on. This is often the best method with veins that are so fine and light that it is easier to draw out the pigment with a wet brush. It is also an appropriate method when creating the semi-transparent, crumpled silk appearance of a newly opened poppy.

On the subject of poppies and other flowers that often have hairy stems or buds, the hairs are drawn in with the brush and never with the pencil during the initial drawing.

Some flowers, such as auriculas, can have golden pollen spilt over dark velvety petals. This can be effectively stippled on with the point of a very fine brush, using a mix of Naples yellow, which is opaque, and a stronger Indian yellow. It will show up on even the richest red or purple flower.

In a freestyle flower painting the subject is never worked up to this degree of detail and the term botanical drawing is not applicable.

LEFT **A vibrant depiction of sunflowers by Jean Elwood using gouache and pencil on mountboard.**

BOTANICAL ILLUSTRATION IN INK OR PENCIL

True botanical illustrations provide the means by which the taxonomist can identify, with a high degree of certainty, a plant from its component parts, including the flower. A drawing will provide information that cannot always be conveyed by words or photographs. For this reason accuracy is essential. The finished drawing can, however, still be regarded as a pleasing piece of artwork.

The first point to note when making the initial study of the subject is its natural habit of growth. Is the plant pendulous, with hanging flowers like a fuchsia, or erect with a stately bearing, such as that displayed by some orchids, lilies, lupins or delphiniums. Are the flowers borne singly or clustered along the stem and, if the latter, are they in spiral formation or growing in a random fashion? This may seem to be very basic but it is important not only for its value in identification but for the layout of the subject on your paper.

We will assume that you are working to life size in the first instance, which is certainly easiest for the beginner. You need dividers and a ruler to obtain accurate measurements and it helps to have scrap paper handy on which to jot down the principal dimensions. Use light pencil marks to convey these measurements, overall width and depth of bloom or leaf, individual petal size and so on, to your paper. Then work a careful outline drawing using an F or HB pencil. If the center of the flower is visible that should be put in with the same degree of accuracy, but there should be no unnecessary embellishment.

Measure the length and width of the stem carefully, and in the case of a very long stem it is permissible to make a clean break at a reasonable

ABOVE RIGHT This study of pine cones by Julie Small proves once again that a detailed pencil drawing can be a work of great beauty. Time and patience are needed and luckily there are still a few artists left who are prepared to create such work.

RIGHT A classic study by Valerie Oxley of an everyday object which captures the texture of the garlic skins to perfection. 2H, F and B pencils were used on Arches Hot Pressed paper.

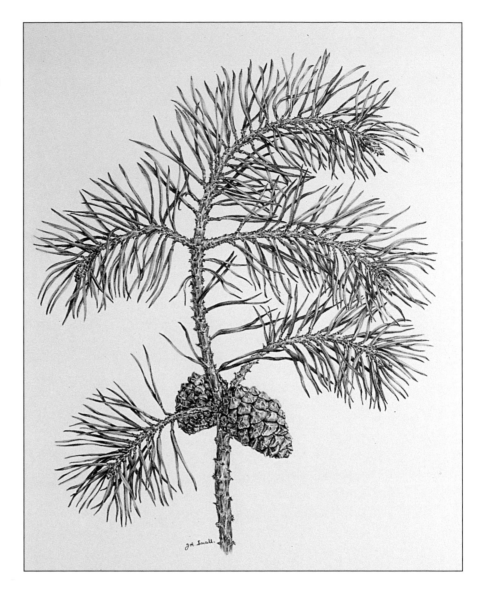

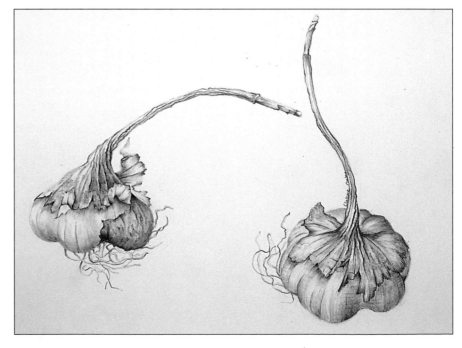

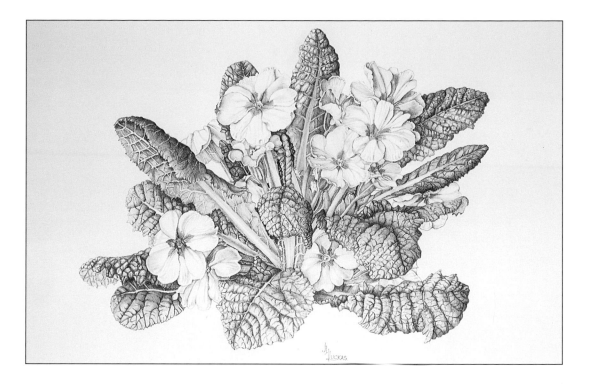

distance from the bloom and continue it a little to one side. This indicates to the observer that it was too long to show completely. The leaves should be measured and drawn in the same manner as the flower, this time with careful attention to the veins, which often hold the clue to the plant species. Any hairs on stem, or flower, should be lightly drawn in.

The key to a botanical illustration of this type is to draw in exactly what you see, without guesswork. No one expects microscopic detail when the subject is observed with the naked eye alone.

Having achieved a satisfactory outline drawing a degree of shading may be necessary. Remember the shading in this case is not a substitute for color and is only done to give added form to the representation. Think of a primrose leaf, networked with veins which are highly visible. If these veins are just set down without shading it appears to be a flat leaf. Only by adding shading can you convey the

A B O V E **An exquisite drawing by Joy Luckas using F, HB and 2B lead pencils. Not only do the leaves act as a foil for the white primrose but the beautifully portrayed venation conveys texture. Note the shading away from the veins, which gives the "cushioned" effect.**

A B O V E **A detailed study of this orchid, _Cypripedium balaclava_ × _spicerianum_, shows its parts and growing habit. Ann Thomas has executed the drawing in 2B and 4B graphite and 2B lead pencils.**

impression of the irregular surface of the leaf with the little "cushions" of leaf tissue across the lamina. This adds texture to the visual content of the drawing.

You will find that for a botanical illustration hatching is the best method of shading with a pencil. Blending with pencil or finger tip is inappropriate. You can apply several layers of pencil, with the strokes running at different angles. This is called cross-hatching. Do not allow it to become too heavy, and above all follow the natural growth of your subject, particularly in the final layer. As a leaf newly unfolds, so the pencil lines should emerge from the midrib and away from the veins. To work against the grain will look unnatural and inaccurate.

There is often less need to shade petals unless you need to show a particular twist or curl. Blotches, spots and other distinguishing marks can be added, but do remember that shading is used only to emphasize form and not as a substitute for color.

IRIS

M A R G A R E T S T E V E N S

A study in ink on Hot Pressed watercolor paper, which demonstrates the stippling technique used in botanical illustration.

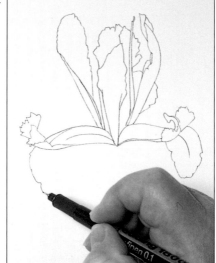

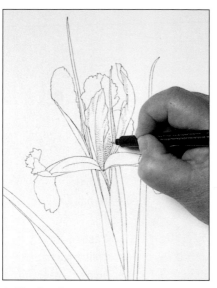

1 A perfect iris is the ideal specimen for an exercise of this type.

2 The artist makes an initial drawing using a 0.3mm technical pen. Every effort is made to achieve accuracy in positioning the petals.

3 The first lines of dots, which model the curves of the flower, are drawn.

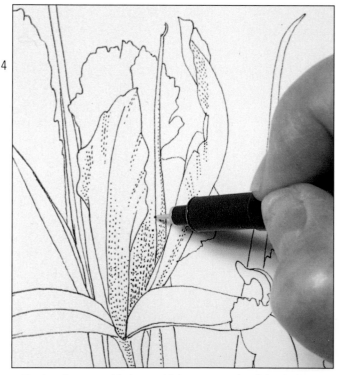

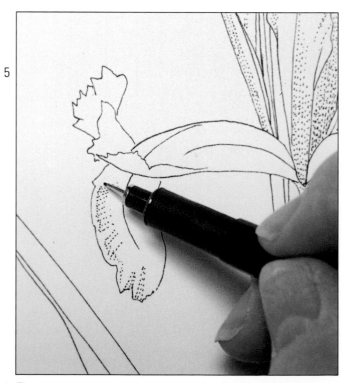

4 Further dots are added to mold the curve to the right shape.

5 The artist stipples the fall of a petal, showing its crinkly edge.

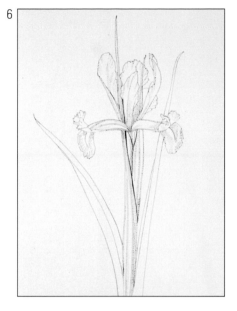

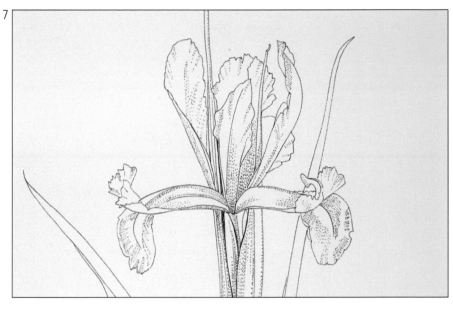

6 You can now see the overall appearance of the iris at around the halfway point.

7 This close-up of the actual flower shows you the amount of stippling necessary to indicate the form of the bloom – *not* its color!

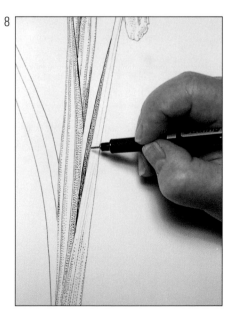

8 The artist works long rows of dots following the straight line of the leaf. These are overlaid as necessary with other rows of dots, to build up a degree of depth.

9 The finished flower study should be clean, simple and accurate.

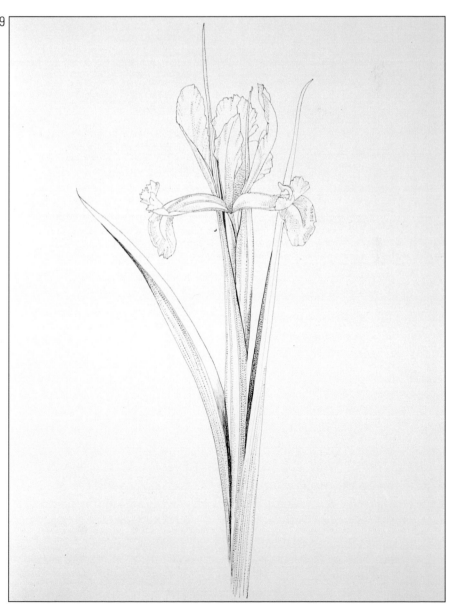

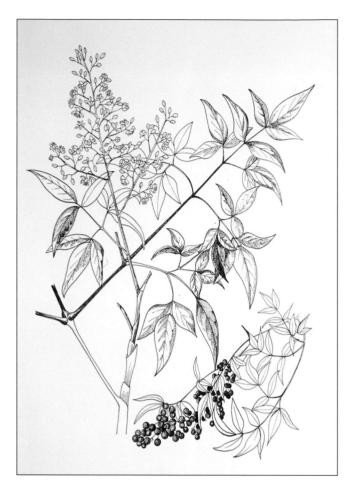

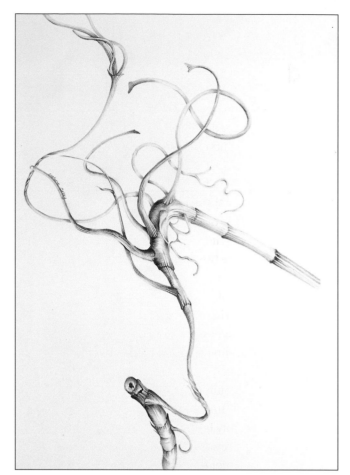

In the case of an ink drawing, unless you are very experienced it is often best to do the initial outline in light pencil, so that you can erase errors if necessary. When you are satisfied that the outline is as good as possible you can work over it with ink. Certainly you need a great deal of confidence to produce the long sweep of a stem with a perfect ink line. Midrib and veins should be drawn in and any very fine detail added with either a mapping pen or with technical pens in various gauges. Instead of cross-hatching as a method of shading you will find that stippling produces an attractive, clean image. This is something to practice on spare paper, as, contrary to uninformed belief, it is not achieved by a mass of random dots. The dots need to be laid down in a series of lines, with

the pen held fairly upright and again following the line of growth. Anything else will just look an untidy mess. Shading can be darkened by applying a second, or indeed third layer of dots, but, unlike pencil cross-hatching, they must all follow the same direction.

If one needs to reduce the subject being illustrated it is as well to work out all the measurements before starting to draw. The easiest method is, of course, to reduce by half, but remember that you must reduce *all* parts of the plant and while the flower overall may be easily dealt with, some parts, such as the stigma, may be rendered too small to be practical. Often reduction by one third gives a more manageable size. In any case, reduction is not as difficult as is often feared and anyone capable of simple division and subtraction will not find it a problem.

While it is appreciated that not every artist who draws flowers will need to produce such precise drawings, it is nevertheless worthwhile knowing and practicing the techniques involved. If nothing else it aids observational skills and manual dexterity.

DRAWING TO ROYAL HORTICULTURAL STANDARDS

Britain is fortunate in having the Royal Horticultural Society where artists who long to draw and paint flowers to the very best of their ability are encouraged to show their work. At the four Winter Shows, held in London between October and February, artists come from all over the world to display their pictures in the hope of pleasing the judges and obtaining a good award.

These awards take the form of medals, bronze, silver and silver gilt, with the Society's gold medal as the ultimate accolade. There is also the Lindley medal in silver or silver gilt for work of outstanding educational or scientific interest.

Although most countries have prestigious Horticultural Societies or Garden Clubs, only in Britain is botanical painting rewarded in this way, so it is no wonder that the internationally recognized awards attract artists from South Africa to Australia and Canada. At a recent show, of the 26 entrants eight came from as far afield as Ohio, Arkansas and Cape Province.

The guidelines for exhibitors are simple. The botanical subject, be it flower, fruit or vegetable, must be portrayed accurately with regard to size, line and color. If you feel inclined towards this beautiful art form you would be well advised to visit one of the shows when such paintings are displayed. You will probably be amazed at the diversity of subjects and styles on show, proving, if it were necessary, that botanical art is not synonymous with rigid, rather boring and lifeless pictures.

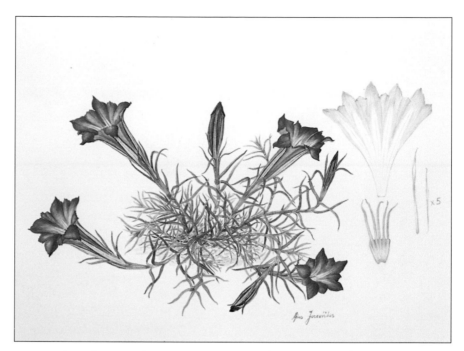

ABOVE One of a series of gentian studies by Aino Jacevicius. Apart from the accurate depiction of the flower, *Gentiana × macaulayi* "Kidbrook Seedling", in line and color, the form of growth is also shown. The flower has been dissected and the petals and sepals spread out to show their form and size. With a tubular flower of this type very sharp nail scissors are best for cutting the flower open, and then it can be held securely to a sheet of paper using double-sided sticky tape.

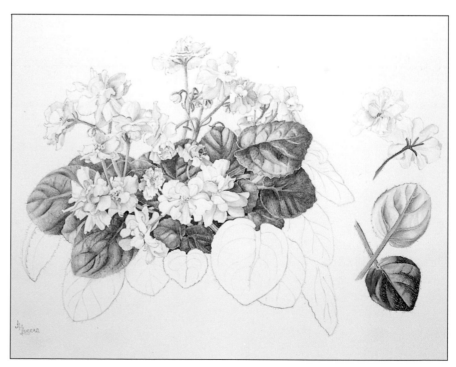

ABOVE This pencil study of *Saintpaulia* "Starry Trail" by Joy Luckas is an excellent example of the various stages in a botanical drawing from the initial outline through to the detailed shading of petal and leaf. Note the hirsute textured leaves. The back of the leaf is equally important and shows the smooth texture of the lamina. Hairs on the upper surface have been executed with tiny strokes of white paint using a finely pointed brush.

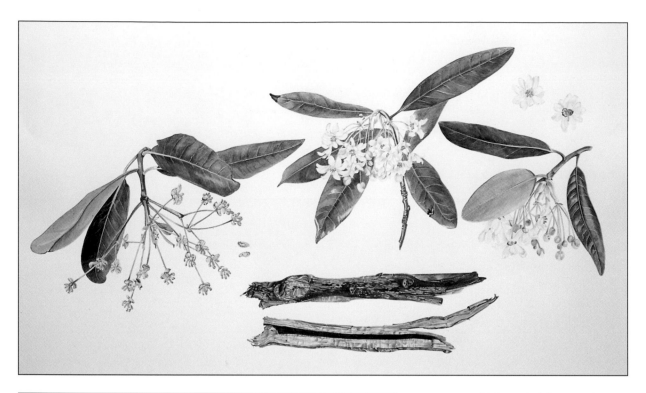

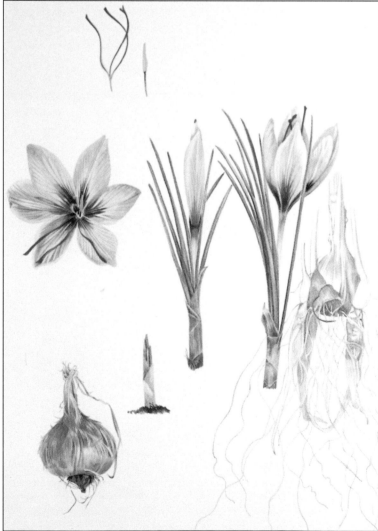

ABOVE This botanical drawing of *Drimys winterii*, a native of South America, by Margaret Stevens, highlights a particular feature of this plant. Apart from covering all the usual features through brush drawing and dry-brush work, it also includes a small section of branch, cut in half to show the bark and spongy core. This tastes and smells strongly of citrus. No surprise therefore to find that it is rich in vitamin C and that the bark was given to sailors in bygone days as a substitute for fresh fruit or vegetables. It is always worth recording any special feature of a plant in this manner.

LEFT A drawing of the autumn crocus, *Crocus sativus* var. *cashmerianus*, by Margaret Stevens, showing the development from the bulb, before planting, to the first shoot and on to the mature flower. Finally the bulb is dug up and its roots are gently washed under the cold tap before that, too, is drawn.

OPPOSITE These magnificent ivy leaves, *Hedera* "Ravensholst", by Kay Rees-Davis, again demonstrate the function of the brush as a drawing instrument where its use with clean water allows the artist to remove delicate lines of paint to create veins. Controlled washes and tiny brush strokes build up the smooth surface of the leaves.

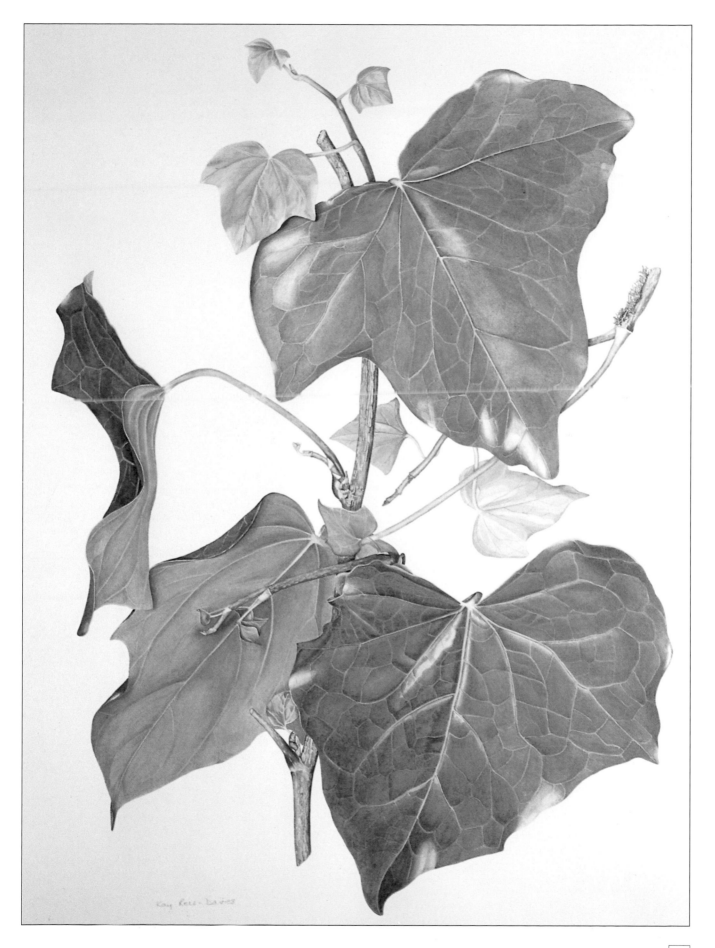

Kay Rees-Davies

CENTERS OF BOTANICAL ART

In other countries some galleries have a reputation for high quality exhibitions of botanical art, for example the Everard Read Gallery in Johannesburg. In the U.S.A. the Hunt Institute for Botanical Documentation at the Carnegie-Mellon University of Pittsburg, Pennsylvania, not only holds a vast collection of botanical drawings by leading artists from all over the world but stages a highly acclaimed exhibition every five years.

The Lindley Library of the Royal Horticultural Society in Britain has a fine collection of work by probably all the famous names of the past as well as many contemporary artists.

DRAWING TO EXHIBIT

It can take several years to produce a Royal Horticultural Society exhibit drawing and the three pink narcissi shown here illustrate one of the reasons for the time involved. If all the pot-grown bulbs choose to flower at the same time you can only capture the main features of some varieties and wait patiently for a further year before completing the study. Therefore, in year one "Pink Paradise" only received its bud and flower, full-face and in profile. "Salmon Trout" did a little better with the first stem and leaf. "Pink Charm" was one of the half dozen completed.

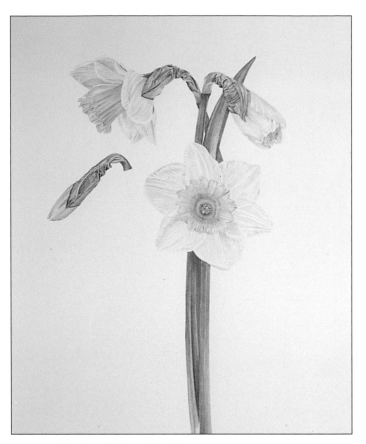

ABOVE *Narcissus* "Salmon Trout".

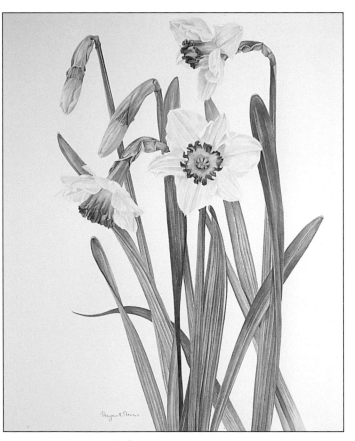

ABOVE *Narcissus* "Pink Charm".

12
DRAWING ON
DIFFERENT SUPPORTS

Most artists like to experiment, trying either new techniques, media or supports. Although there is a fine variety of papers to choose from, many students want to know something of the traditional, indeed, historical materials, and to try the skills which accompany them. It is perhaps typical of mankind's contrary nature that as daily living becomes more frenetic many turn to art forms from a slower, more dignified age. We find classes in calligraphy full of captivated students and alongside them dedicated followers of the miniaturist's art. Apart from the pleasure of producing small pieces of jewel-like quality, there is the added pleasure of working on different supports, such as vellum and ivorine.

The botanical artist needs to be a patient person so small wonder that he or she frequently enjoys working in miniature. The combination of flowers, in miniature, and calligraphy, is a noble art with its roots firmly established in centuries-old tradition. In order to take even the first step into that world one needs to know a little of the method.

A miniature painting is executed using hundreds, even thousands, of tiny brush strokes, but this is not our main concern here. Before the painting comes the drawing. Originally vellum was the normal support, then ivory became popular. Now, in this age of conservation, real ivory is frowned upon, apart from the occasional piece of old ivory which is used – old piano keys or leaves from card cases, for example. Most artists work on a plastic substitute, ivorine. In color and texture it is excellent. It can be cut with scissors but care must be taken not to handle it with exposed fingers. Even a small amount of grease from the skin will render the surface unworkable. So pick it up carefully with a piece of paper towel or tissue, between finger and thumb. It is best if you scale down your subject on ordinary drawing paper so that all preliminary work is done before drawing on the ivorine.

The beginner may choose to take advantage of the translucent nature of the material and trace through onto the surface of the ivorine from a clear drawing placed beneath it. A light outline with a lead pencil sharpened to a good point is all that is required. Be careful not to apply too much pressure or use a soft pencil, or graphite. No trace of this outline must show in the finished work.

If you make a mistake you cannot use an eraser without spoiling the surface of the support. The result will be the same as if you touch it and subsequent paint will not adhere. Any error can be corrected by washing the ivorine under the tap in cold water and gently rubbing with a pad of paper towel dipped in ordinary powder washing detergent, *not* washing up liquid! Rinse and blot dry, then leave for a short while before starting again. Alternatively, you might use a well-pointed sable brush such as those made for the miniature artist and graded down to 000. Some artists are more comfortable working with a larger, say size 3 brush, throughout. It is the quality of the point that counts.

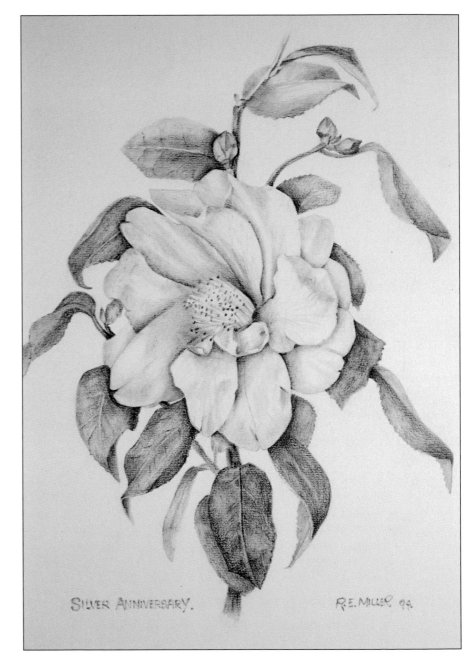

ABOVE This pencil study of camellia "Silver Anniversary" by Robert E. Miller has Fabriano Cold Pressed paper as its support. The "linen weave" surface softens the shading and allows the tooth of the paper to show through, particularly in the darker areas of the leaves.

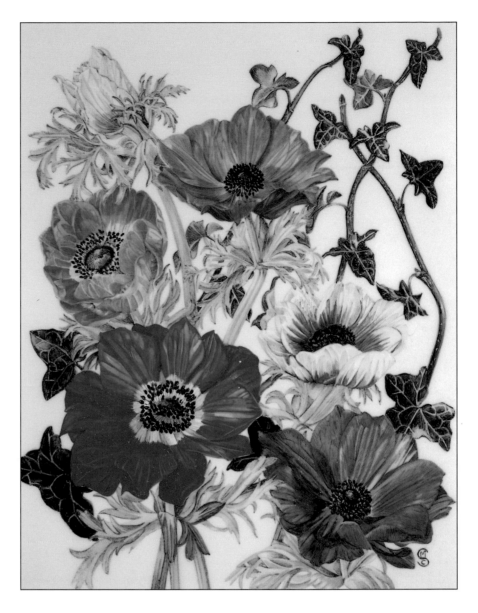

This drawing of anemones by Margaret Stevens shows the working method for drawing on ivorine. The initial drawing can be planned on layout paper and then traced through to the ivorine, using a fine pencil line.

RIGHT **Watercolor on ivorine is used for this study of anemones and uses the technique employed by the miniature painter. A combination of wash and very fine brush strokes builds up the subject with jewel-like color. (Reproduced by courtesy of the Revd R. C. Wallis.)**

Whichever brush you choose, use it to apply a fine outline in paint, say a pale cobalt blue.

One tip that is certainly worthwhile remembering is to make sure that each time you dip in the waterpot you remove all surplus water from the brush and particularly from its metal ferrule. There is nothing more frustrating than to be near completion of a piece of work after many hours (working in miniature is not for the impatient), only to have a water droplet run down the ferrule onto the work. It can take hours to repair the damage.

A miniature can range in size from smaller than a thumbnail to 6 × 4½in (15.5 × 11.5cm) overall, including the frame, and in a true miniature no component of the subject should be greater than 2in (5cm) in diameter.

Working on vellum is more difficult because you need to be totally accurate with the initial drawing. Erasing and washing out are both out of the question. In the first case residual lanolin in the skin will surface and however minute the quantity it will prevent paint from adhering. In the second case you only have to drop a piece of

prepared vellum into water and see the result – a curved, rock-hard piece of material closer to shell than skin.

Because you cannot see through it tracing is no help and so your "right first time" drawing needs careful preparation on paper beforehand. Then, using a hard lead pencil lightly, relax and draw in your own good time. The result will be well worth the effort as both ivorine and vellum allow the colors to glow with real brilliance.

The experienced artist sometimes chooses to paint on larger pieces of vellum, when the size of the subject is dictated by the size of the

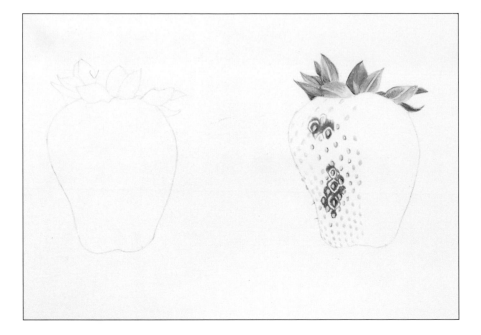

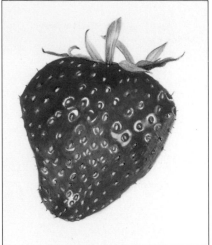

A B O V E Pencil and watercolour on vellum by Margaret Stevens. This demonstration piece of a strawberry shows the thin gray line of pencil that forms the outline and the detailed brush drawing that builds up the whole fruit.

R I G H T This silverpoint drawing of blossom, on specially prepared paper, shows the fine line and delicacy that such a medium allows. The color will change as the silver tarnishes.

available skin, but for the beginner it is wiser to stick to sheets that can be purchased ready prepared measuring 8 × 5in (19 × 13cm). Ivorine, too, can be purchased in 8 × 6in (20 × 14.5cm) sheets, making both very suitable for small pictures other than miniatures. With either material it is best to work with a large sheet of white paper beneath and to hold the support in place with tiny pieces of masking tape attached to that part that will ultimately be unseen in a frame.

The delicacy of silverpoint is attractive for the discerning artist and viewer alike. Pre-dating any form of pencil, it enables the artist to draw finely and to watch as the metal tarnishes and the initial gray

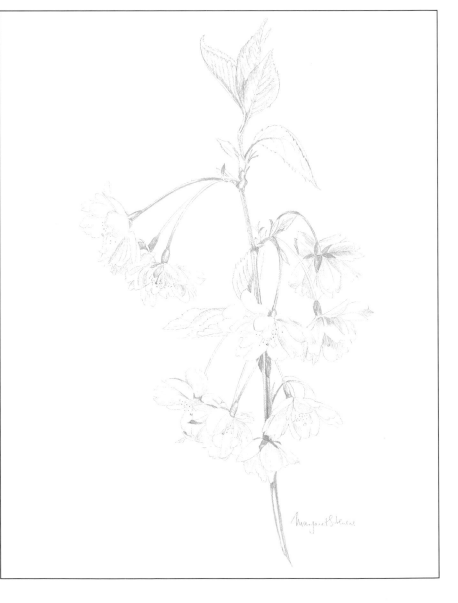

line turns to a soft brown.

You will need short lengths of silver wire in varying thicknesses and a metal clasp holder to use them. Paper can be purchased ready prepared or, if not readily available, it is simple enough to prepare yourself, in order to have a surface on which the silver can grip and deposit the metal particles which create the line. The paper needs to be smooth and stretched in the usual manner (see page 125). Then when it is dry, apply a wash of white watercolor, or gouache if you prefer a more noticeable background. Alternatively, you may like to try a tinted wash, such as lilac or pale blue. The finished drawing can then be highlighted with white paint if you so desire. In either case, leave the wash to dry thoroughly before starting your drawing. Remember that new lengths of wire may be sharp at the tip so gently rub them on glass paper to prevent damaging your paper.

Finally, a few words on drypoint – a form of intaglio printmaking. In this process the drawing is traced onto a zinc plate, then, using a solid tapering steel point the surface is scored along the traced lines. This raises the surface of the metal to form a ridge and by varying the pressure on the steel point a combination of delicate and strong lines is obtained. Darker tonal values can be achieved by more frequent and deeper scratches, which if overdone can be smoothed with a burnishing tool until they are lightened to your satisfaction. When you are happy with the composition printing ink is rolled thinly onto the plate and becomes trapped in the raised metal ridges and scratches. Excess ink is wiped off and the plate is placed on the bed of an etching press where it is covered with damp paper and subjected to pressure from a roller. The ink transfers to the paper, thus forming the drypoint print. Many copies can be made in this fashion, although later ones may lack the clarity of the early prints, as the soft metal ridges wear down. This is a simple process when compared to other methods of intaglio printmaking, with no acid or other substances involved.

EXPANDING YOUR SKILLS

It is generally recognized that flowers, with birds and animals in hot pursuit, are favorite subjects with designers in many fields. Landscape plays a far less significant role and the human body even less so. A walk through the shopping center in any town will confirm this. Look at all kinds of merchandise, from greetings cards to stationery, fabrics and household linens to china and wallpaper, and you will follow a very flowery path.

Many people attending art courses wish to build on their love and knowledge of flowers to produce better line drawings for use when following a traditional craft. Sometimes their sights are set on commercial success, but more often it is for the sheer pleasure which they obtain from creating a thing of beauty.

LACEMAKING

Often it is the ability to strip the flower of all its unnecessary elements while still retaining its recognizable character that is the true basis of good design. One example of this is the maker of true Honiton lace, that most intricate of skills who, by the many dedicated hours involved in the creation of a piece of work, makes even the slowest of botanical painters seem like a hare. No matter how delicate the final lace may be, the starting point is a line drawing on paper.

ABOVE **A design by Tessa Holmes for a jabot and cuffs worked in Honiton lace for the first woman to hold office as High Sheriff of Merseyside. The design** incorporates the famous Liver Birds of Liverpool, the Lancastrian rose and stephanotis. This piece took 10 months to complete.

POSTERS

One of the most frequent demands made of a flower artist with recognized design ability is to create a poster for this or that exhibition or function. Not every artist necessarily has that skill, so those who do are valued in the community. Since the arrival of comparatively cheap color photocopying such posters can be very ambitious, but black and white designs are still almost unbeatable for impact and attracting the eye of the passer-by.

These are just a few ways in which the flower artist may expand his or her skills. Many people never aspire to working professionally but derive much pleasure for themselves and give pleasure to others by the beauty of their creations in other fields.

ABOVE **A typical example of an ink drawing used to good effect by Hilary Leigh to create an eye-catching poster.**

ABOVE **This elaborate poster by Margaret Stevens builds on the traditional subjects of ivy and Christmas roses, using 22ct. gold leaf to highlight stamens and veins.**

SILK PAINTING

Freestyle flower artists can really come into their own by working on silk. Impressionist or abstract work as well as more structured designs become stunningly beautiful when combined with the translucence of pure silk. The silk is stretched tightly onto a frame suspended above the work surface. Then the paper on which the design is drawn is attached to the underside of the silk with masking tape and the outline traced onto the material with gutta-percha. This is applied from a small plastic bottle with a metal "nib" attached. The thin line of gutta-percha keeps the paint within a desired area. Different colors will blend while the paint is still wet and various effects can be achieved by droplets of water falling on the paint before it is dry. The painting is finally steamed in order to set the colors. The result is either a very beautiful scarf or may be mounted and framed as a picture.

EMBROIDERY

Embroiderers, too, benefit from the ability to draw flowers which are the foundation of so many pieces of work, whether in counted cross-stitch or needlepoint. In the case of the former, a drawing may be done at any time and later adapted for use. Transparent graph paper is laid over the drawing, the scale of the graph paper determined by the size of the drawing. With a sharp pencil the outline is followed as closely as possible by means of the vertical and horizontal lines of the graph paper. Thus the drawing is converted into squares and becomes the working design for the embroidery. Each square on the graph paper corresponds to one stitch on the embroidery material.

Working on canvas is not dissimilar. You may prefer to "draw" a very basic outline freehand directly onto the canvas with a fiber-tipped pen, and then "paint" with the tapestry wools, blending the colors as if with a brush.

RIGHT AND BELOW A working drawing (right) by Joan Field of water lilies intended as the central motif on a hand-painted silk scarf together with the completed scarf (below) by Joan Field.

CHINA PAINTING

Another increasingly popular skill, with a worldwide appeal, particularly in Britain and the U.S.A., is that of china painting. Diploma courses are available and it is not unknown for both teachers and students to attend classes in flower portraiture in order to practice their drawing skills.

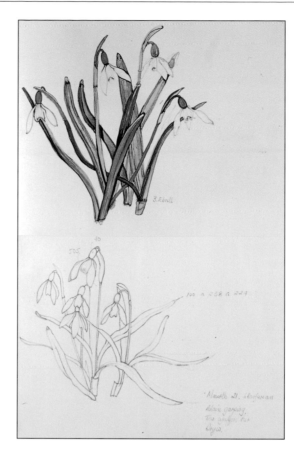

RIGHT, BELOW RIGHT AND LEFT
The initial colored ink drawing of snowdrops by Ann Thomas is adapted on graph paper and finally executed as a counted cross-stitch embroidery.

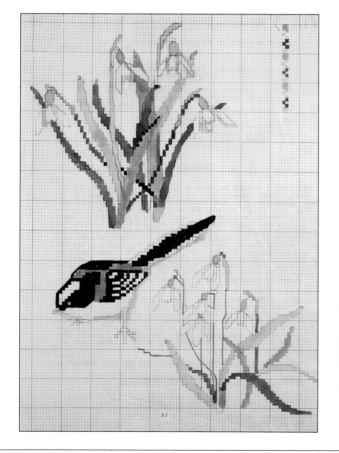

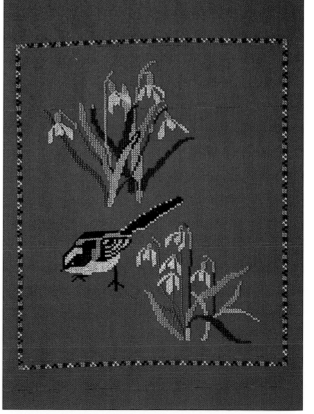

ANALYZING AND IMPROVING

The true artist hopes to improve his or her abilities throughout a lifetime. Even the professional working in the relative seclusion of a studio needs to emerge at intervals to meet and talk with other artists and to face the criticism of peers. That way the mind is stimulated, new ideas emerge and there is no risk of stagnation.

What is right for the professional artist is equally right for the amateur and student. If anything, it is even more important to mix with other like-minded people. To face criticism is important and to take that criticism well without being hurt is vital in the struggle for success. Remember that someone else looks at your work with fresh eyes and can often see immediately something that you have overlooked. It is often work completed hurriedly or executed under pressure which is likely to attract the most adverse criticism. Then your sense of anger or frustration is best directed at yourself rather than at the person who has the courage to speak the truth.

Self-criticism is also important, but there is a right and wrong time to do it. There is little value trying to pull your work to pieces after you have just spent hours slaving over it. Your eye will be jaded and your judgement unsound. Far better to leave it for several hours and then look with a clear eye. It is often useful to look at your current work last thing at night when you may scarcely recognize it from when you last saw it in the studio. This late-night viewing usually means that you go to bed knowing which direction to take next day.

ABOVE In this drawing of a camellia, Hilda Lloyd uses stippling as a shading technique.

LIGHT
→

FADING FLOWER ON RIGHT IS IN WRONG POSITION. WOULD PROBABLY BE MORE CORRECT TO THE BACK OF MAIN SUBJECT

WE 4/9/93

ABOVE A page from the sketchbook of Wilf Elliot, a man who has a great love for pansies. His note shows that he has realized that the fading flower would have been better depicted growing from the "back" of the plant, rather than creating a harsh angle in the foreground.

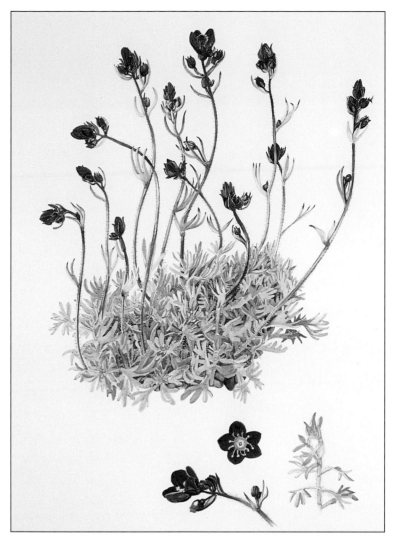

A B O V E **Another detailed saxifrage, this time "Welsh Dragon", a new variety whose very dark red color extends into the stems.**

Drawn by Joy Luckas, the dense, mossy growth challenges the artist, as do the very hairy leaves and stems.

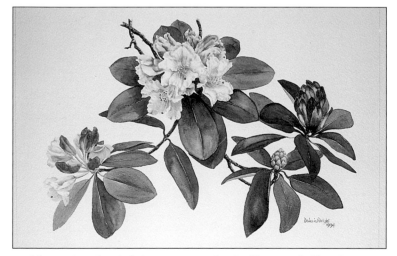

A B O V E **A free watercolor study by Valerie Wright on rough paper, spontaneous in line and color, and**

inspired by an early-flowering rhododendron seen in a Scottish garden.

Botanical artists, even those who work professionally, tend to return to the Royal Horticultural Society to exhibit and be judged, whenever they have the time to prepare sufficient work. That way their standard is maintained and there is less risk of a decline in the quality of their work as they become, perhaps, more involved in commercial projects. For the freestyle artist there are a number of societies at which they can exhibit, and leading arts magazines will usually give details of these and where open exhibitions are to be held.

There are also many courses available for both styles of flower painter, and you should make sure that the course offered is suitable for your style of interpretation. As well as courses run by local authorities under the adult education banner, there are many private courses available both at home and abroad.

If tuition is not an important factor then it is as well to join a local art society. There you can perhaps meet to paint together at regular intervals throughout the year, with the added incentive of an annual exhibition to work for. Some regions have societies for the more advanced artist, or professional, living and working away from the metropolis. Admission to these societies is often by selection and the standard can be quite high. It will also probably be a society which welcomes members of all disciplines, be it portrait, landscape or flowers.

The same maxim always holds good for all artistic endeavors. Observe and practice, and if some of this looking and drawing is carried out in the company of friends, then so much the better.

14
PRESENTATION
AND CARE OF WORK

It is important to present your work as attractively as possible. A drawing that has taken up many hours of your time deserves the best, not only for appearance's sake but also in order to ensure its long-term preservation. In some cases the first step to good presentation begins even before the artwork is started. This particularly applies to watercolors, for which unsuitable lightweight paper may be chosen. If the error is compounded by neglecting to stretch the paper and a lot of water is used, the picture is doomed from the start. No one appreciates a painting on an uneven, buckled support.

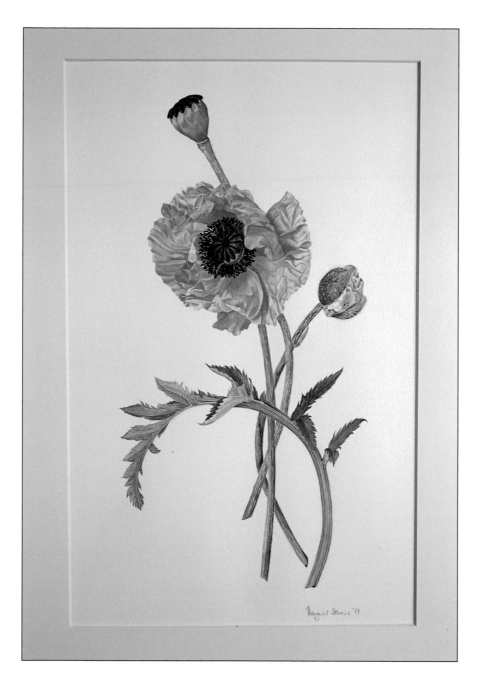

knife or razor blade, making sure that you cut opposite sides in turn – as you stuck it down. This ensures that the paper will not split as the tension is released.

FIXING DRAWINGS

Pencil and pastel drawings may be fixed if they are going to be subjected to much handling, but they are best stored in a folder with tissue paper between them. A double mount helps to protect pastels, certainly before they are framed and glazed.

MOUNTING AND FRAMING

A good drawing can lose value in a poor frame. A good frame cannot improve a poor drawing but it can enhance and show a good picture to its best advantage.

Mounting and framing is best left to the experts. It can be a fairly expensive job but it is certainly advisable if the work is to go on exhibition. If you are determined to do your own framing it is worthwhile attending a course to receive instruction, so that the result is as professional as possible. Remember that the master framer has equipment and a choice of cards and moldings not always available to the amateur,

STRETCHING PAPER

Use a substantial wooden board, not chipboard or plastic. Cut the paper approximately 1½in (4cm) less in diameter than the board. Lay the paper on the board and use a sponge to wet it evenly. While the water is soaking in, dry your hands and cut strips of gummed paper, each about 2½in (6cm) longer than the sides of the paper. By the time you have done this the paper will

have absorbed the water. Dampen the gummed strips and stick down the paper, one side and then its opposite side in turn. Make sure that half the width of the paper strip overlaps the drawing paper, so that there is plenty of grip to hold the paper as it dries taut. Leave to dry *flat*, away from direct heat. This will take at least overnight. After you have completed your picture cut the paper off the board, using a craft

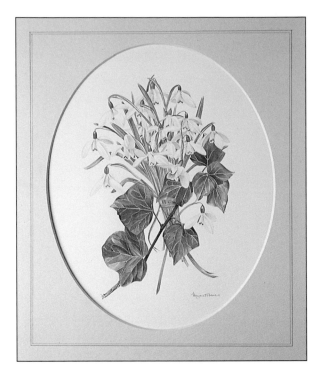

ABOVE **This study of snowdrops by Margaret Stevens is best displayed in an oval window mount.**

ABOVE **Beautiful Christmas roses by Margaret Stevens in a more elaborate mount, ready for framing.**

not to mention sophisticated cutting machines and so forth.

Although many paints, pencils and inks are lightfast it is wise not to subject any artwork to direct sunlight. This is important when hanging pictures in the home and storage is best in folders kept away from any light. Most framers will recommend acid free board or conservation board for mounting and backing pictures, as an added protection.

It is best to fasten the artwork only at the top of the mount. This enables the paper to breathe and respond to changes in humidity, so there is less likelihood of it cockling in the frame.

Do not be tempted by the many elaborate moldings which are available. Most flower pictures look best with relatively simple mounts and frames, allowing the beauty of the flowers to dominate.

SELLING YOUR WORK

It is probably true to say that the artist who specializes in flowers has a better than average opportunity to "get into print". Greetings card companies alone provide an opening for many artists, as floral subjects are always popular. However, the standard of work required is extremely high and you might expect quite a few rejections before having any work accepted. If you have ambitions in this or any similar field it is important to get to know the market. That means, in the case of greetings cards for example, looking at those in the shops and deciding which are compatible to your style. Never send unsolicited artwork without this preliminary enquiry.

You may choose to publish your own work, as cards or even prints, particularly if you have knowledge of a sales outlet – always easier if you

live in a tourist area. This is quite an expensive step to take and care is needed to find the right printer and to check out other examples of his work. Nothing is more disappointing than to see your good artwork reproduced badly. Remember also that the actual profit on the exercise may well be tied up in the last prints or cards, the earlier sales simply recouping your costs.

Whatever your ambitions, whether to see your work in print or simply to enjoy portraying flowers for their own sake, you can be assured of many hours of relaxation and pleasure when you turn your attention to the art of drawing flowers.

GLOSSARY

Botanical drawing The realistic and accurate method of illustrating plants that combines both their scientific and esthetic qualities.

Cold Pressed paper see NOT.

Composition The arrangement of the subject matter in a way that is harmonious and pleasing to the eye.

Cross-hatching A method of shading in which successive layers of pen or pencil strokes are applied at right angles to each other.

Dicotyledon A flowering plant with two embryonic seed leaves, such as members of the daisy family. See also monocotyledon.

Drypoint A method of engraving that does not require the use of acid.

Felt-tip pen An inexpensive, disposable marker, available in a wide range of colors, not necessarily lightfast.

Fiber-tip pen A disposable pen with a fine grade tip, ideal for an even width line.

Fixative Made from synthetic resin, fixative can be used to seal pastel or charcoal drawing. It can be toxic and should be used outdoors.

Foreshortening A perspective term applied when one is representing an oblique object to one's line of vision.

Form The appearance of the subject matter – its line, contour and so on.

Gouache An opaque medium in which the colored pigment is mixed with white or bodycolor.

Graphite The mineral used in the manufacture of "lead" pencils, which are either made of pure graphite or graphite and clay.

Hatching Shading by means of a single layer of pen or pencil lines.

Highlight The point on an object that reflects the greatest amount of light.

Hot Pressed paper Paper that has been hot pressed and the surface "ironed", so that the fibers have been smoothed down.

Indian ink A black, permanent ink, usually with a shellac base.

Mapping pen A dipping pen with a fine metal nib.

Mixed media Any painting or drawing technique that employs several materials – e.g., ink, watercolor and pastel.

Monocotyledon A plant that bears only one seed leaf – e.g., those of the lily or onion families.

NOT Paper that is not Hot Pressed, also known as Cold Pressed. Rough paper acquires its surface by being pressed between a blanket. Cold pressing is applied to rough paper and flattens the surface texture.

Oil pastels Pastels in which the pigment is bound with waxes.

Perspective The way in which the effect of distance is represented graphically.

Picotee The finely colored edge found on the petals of some bi-color flowers – e.g., some carnations.

Pigment A color that is solid, as opposed to a dye, which will stain only when mixed with another substance.

Plasticizer A substance, usually glycerine, added to watercolor paint to improve its brushing and soluble qualities.

Propelling pencil An automatic or clutch pencil with renewable leads, graded in the normal manner from hard to soft.

Sanguine A mixture of iron oxide and chalk that was used to give the red color often used as a drawing medium with charcoal and white chalk. Now available in conté crayons.

Sepia An organic brown, semi-transparent pigment. Similar to burnt umber.

Shading The means by which a three-dimensional appearance is given to a two-dimensional drawing; the application of light and dark tones.

Silverpoint Silver wire used to make a drawing on specially prepared paper.

Stippling A method of shading that uses dots instead of lines.

Support The paper, board or canvas and so forth, on which the drawing or painting is made.

Technical pen A pen with a fine tubular metal nib which gives fine lines of constant thickness. The ink is supplied from an independent cartridge.

Texture The term used when the artist conveys the "feel" of the subject, not just its form and color, but a furry leaf or a velvety petal.

Tone The variation in color, lightness or darkness of a subject.

Tooth The texture of the paper surface that allows pigment (particularly pastels) to "bite" and settle with varying density.

Wash An application of watercolor paint, often diluted to the lightest tone, as a preliminary stain, on which subsequent, often more detailed work will be executed.

Watersoluble pencil Colored pencils that can be used with water to give a watercolor effect.

INDEX